TANTRA

TANTRA

The Indian cult of ecstasy

PHILIP RAWSON

with 190 illustrations, 32 in colour

THAMES AND HUDSON

Contents

Introduction 7

The Plates 33

Documentary illustrations and commentaries 98

 I *Ritual and worship* 98

 II *Sex and reality* 102

 III *Krishna* 105

 IV *Death and fire* 107

 V *Cosmic diagrams* 111

 VI *The subtle body* 116

 VII *Meditative diagrams* 121

 VIII *The approach to unity* 125

ACKNOWLEDGMENTS
Objects in the plates are reproduced by courtesy of the following:
Jean Claude Ciancimino, London 4, 5, 9, 23, 43, 52, 56, 60
John Dugger and David Medalla, London 1, 61
Sven Gahlin, London 19, 22, 29, 47, 49, 53
Gallery 43, London 2, 64
Philip Goldman, London 13, 16, 41
Gulbenkian Museum, Durham 68
Alistair McAlpine, London 42
Ajit Mookerjee, New Delhi 6, 7, 8, 10, 12, 14, 17, 18, 20, 21, 22, 28, 30, 31, 32, 33, 34, 35, 37, 39, 40, 47, 48, 50, 51, 54, 55, 57, 59, 63, 67
Oriental Institute, Baroda 24–7
Victoria and Albert Museum, London 15, 45, 58, 65, 66

Photographs are by the following:
Werner Forman 2, 13, 41, 64
Richard Lannoy *Documentary ill. no. 70*
Jeff Teasdale 6, 7, 10, 12, 14, 16, 17, 20, 21, 24–8, 31–5, 39, 40, 46, 47, 50, 51, 54, 55, 57–9, 62 63, 66, 67. *Documentary ills. except no. 70*
John Webb (Brompton Studios) 1, 9, 15, 18, 19, 22, 23, 29, 30, 37, 38, 42, 45, 48, 49, 53, 61, 65, 68

Introduction

Tantra is an Indian cult; but since it has evolved continuously from the remotest antiquity it is not limited to any of the particular Indian religions which arrived later on the historical scene. Groups of Hindus, Buddhists and Jains share Tantrik ideas and do Tantrik things; but there are symbols in the vast natural caverns of Palaeolithic Europe (*c.* 20,000 BC) which can be accurately matched with symbols still used today by Tantrikas. Hundreds of generations have devoted themselves to developing and refining Tantra, so that it now conveys with extraordinary purity the most essential patterns of human symbolic expression. It is widely recognized that this is what makes it so valuable for people of the present, Westerners as well as Indians.

It would be wrong to call Tantra a religion; that term has too many misleading overtones nowadays for far too many people. Tantra is not a 'way of thought', either. Thought, in the sense of ordinary logical and very useful reasoning, Tantra sees as one of the chief causes for people gradually becoming disillusioned and miserable in what they believe to be their world. So Tantra works with action. Above all, Tantra is not something meant to be read about in books, although in fact there are numerous Sanskrit books known as Tantras. The earliest, a Buddhist

one, probably goes back to the sixth century AD. The most recent are nineteenth century. But what these texts consist of are prescriptions for action, including mental action, which are the whole purpose of the texts. If you don't do what your Tantra describes, then you will never get the point.

The Tantrik pictures this book illustrates were also meant ultimately to be used, not just looked at. They are undeniably impressive; but that is not all. They are made expressly to stimulate a special kind of mental activity, and to evoke psychosomatic forces. Used in rituals which include yoga, offerings, meditation and sexual intercourse, they can change a person completely, providing him with a new basis for his life. At first, all these procedures need to be carried through in the most basic fact; for only in this way can they displace the banal everyday reality which presses so forcibly on people's lives. Later, when a Tantrika reaches a high level of achievement after many long years of effort and assimilation, the pictures may be visualized and carried out subjectively, without any risk of their collapsing into fantasy. For Tantra has no dealings with fantasy. What it describes and maps is a world of realities, a world which can only be visited by following the maps. It is there to be found; but someone who has not visited it can have no idea of what it is like. For there is no way of examining it from the outside. It is what we are—although we don't usually realize the fact—and we can never step out of it to take an analytical view.

Tantra, in fact, plunges one back into the roots of one's own identity, not just by discussing social roles and interpersonal communication, and not by offering the kind of clear-cut or comforting answers given by the dogmatic theology of straight religions. Tantra says 'If you do these things which Tantrikas have discovered, you will find yourself in a position to experience what the truth is about yourself and your world, as directly as you can experience the street.' Needless to say, to do those things, to get into the position from which you can experience the truth, involves a total change of personality. This takes every kind of effort— physical, sexual, mental, moral; and most are just the kinds of effort that nothing in Western education or tradition prepares one for. Tantra calls on energies in the human body and its world which most people usually dissipate in their ultimately pointless exertions and 'recreations'. But, most important of all, Tantra positively cultivates and bases itself on what most people dismiss as the pleasures of life. It does *not* say solemnly 'You

must abstain from all enjoyment, mortify your flesh, and obey the commands of a jealous Father-God.' Instead, it says 'Raise your enjoyment to its highest power, and then use it as a spiritual rocket-fuel.' This, of course, seems a dangerous revolutionary doctrine to the orthodox in any religion. And to the orthodox the Tantrika is a scandal.

Here is an Indian description of what a Tantrik saint looks like to an outsider. He is so happy as to seem crazy; his eyes roll, reddened with wine. He sits on silk cushions surrounded by works of art, eating hot pork cooked with chillies. At his left side sits a girl skilled in the arts of love, with whom he drinks and repeatedly has ecstatic sexual intercourse; he continually makes music with his vina (a stringed instrument), and sings poems; all of which he weaves together into rituals. Everything such a man seems to be and do gives violent offence to the conventionally minded. And that, in fact, is part—but only part—of the point. For he himself has had to break any lingering attachment he may have had to even his own conventional attitudes. What he is doing fundamentally is rousing all the energies he can discover in his body, emotions and mind, and combining them into a vehicle which will carry him towards enlightenment: enlightenment being that state of knowing the truth about the origin of things and men, and their meaning, as clearly as experiencing the street. He uses every possible means, adapting every conceivable emotional stimulus and act to his purpose, on the assumption that things which you actually do repeatedly, and which have associated with them a powerful sensuous and emotive charge, change you far more effectively than anything else. And only if you combine together many different kinds of doing is the change radical.

What exactly is this change? To start with, it is fundamental and total. Tantra has evolved a model of the Genesis of the world, and mapped its mechanism. Into its model each generation of Tantrikas has incorporated the best scientific knowledge available to it. (India, in fact, always was a country of great mathematicians and logicians). We can do something similar for ourselves. The real importance of the Tantrik model is that it plunges straight to the heart of the matter, and confronts the question of time. Most Western philosophy and theology has been content to take time on trust without looking too deeply into it. Tantra has always believed that our failure to grasp time lies at the root of all other human failures. To see the nature of time is to understand the process of Genesis, that ladder of descending stages from the Origin through the evolution

of the cosmos. Once we grasp that, we can, so to speak, reverse the machine for ourselves, and climb back up the ladder of Genesis. To reach that summit of intuition Tantra holds to be the worthwhile goal.

The common-sense, materialistic-scientific view of time most Western people hold is shown in the diagram. It resembles the view we get by looking backwards only out of the rear window of a moving automobile; for we can only look backwards in time, not forwards. Objects appear out of an invisible future within our field of vision, framed in our 'present moment', which defines our immediate sense-experience and knowledge. As time goes by things, as they get older, seem to recede towards the horizon. All things seem as though they must have beginnings and ends. A is a person we have known all our lives who has died. We can 'see' his life entire from beginning to end. Other people and things,

Fig. 1 The everyday view of time and history

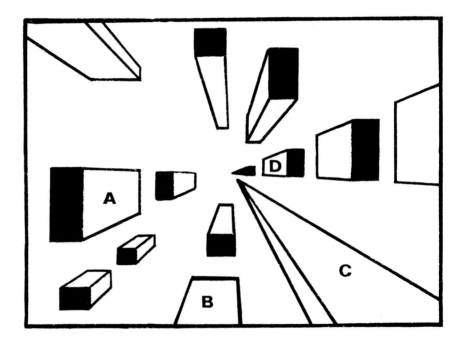

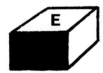

like B, have begun and are still with us. Some existed, like D, far back in history. Others, like the earth, at C, may *seem* to have been always there. But our astronomy suggests that in this kind of time the world may have had an infinitely remote beginning, at the central vanishing point of our view of all things. Once, perhaps, when the world began, the frame of the present moment was at the central point, and all the later boxes in the frame are linked to each other by chains of cause and effect.

But of course, if the frame actually represents any person's sense-experience at a present moment, he cannot really have experienced what the objects even a small way back from him towards the horizon were really like. He has to 'make them up' as mental fictions, helped out by 'scientific knowledge'. We don't any of us really 'know', from our own direct experience, what every moment of even quite recent history was like, or the lives of our friends, or even whether things are there which we don't experience. In addition, we easily forget that we ourselves, as bodies, should each be one of those receding boxes, and that each of us has his own frame of the present which is being formed into a box of its own, which to people looking out through their own frames of the present will look like A. For when we are dead that is how we will look to someone else. But if we ask ourselves what it is we are really seeing, the apparent solidity of A, B, C and D turns out to be terribly insubstantial; for it is composed entirely in our mind out of memories, cross-checked, and fortified by what we hope is accurate information about the past conveyed by talk, books, pictures. On this basis we expect to predict what is to come, reckoning that it is probably related through a chain of causes to what has been seen before, like E, which is outside the frame of the present and has not yet arrived inside it. The whole picture that seems so solid is revealed as a personal mental fiction, supported by fragments of what we agree to call 'fact'. All we really know is the contents of our own memories. Yet we firmly believe that each of us with his own 'present-frame' is in some way moving through a landscape-world composed of solid realities which seem to be arriving into our backward look, even though they tell us nothing about the person who seems to be seeing them, or his relation to them.

Tantra looks at things differently. It thinks of that past full of 'objects', not as a landscape through which each person moves with his 'present-frame', but as a trail of things and events which is, as it were, being vomited out or projected from the mouth of the present, like the flames

from the tail-vent of a rocket. Indian mythology has represented it as if it were seen from outside, as in the diagram below (*fig. 2*).

If we then shift our viewpoint and imagine ourselves looking back outward through the projecting open mouth of the monster (or rocket), just as we did through the automobile window, we get a view of our past and its world not inconsistent with our Western one. It must, of course, look more or less the same. The ancient, distant objects still look far away, almost beyond the reach of our knowledge and experience. We still see things 'receding' from us along the vista of the past into the time-depth of the picture. The real difference is that in this new image time and things did not 'begin' at some imaginary point back in the depths of the picture. They are being projected through each of us; each person's 'present-frame' is itself a mouth of that monster vomiting

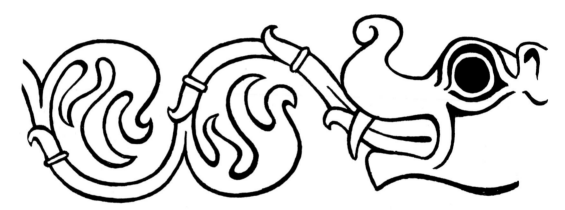

Fig. 2 The monster representing time and fertility

out his world of experience and knowledge. We will never be able to find the origin or causes of all things 'out there', among older projected things. Their origin is in the projection-mechanism itself, that is to say, within the psycho-physical organism. And what is being projected is the tissue of experience and memory we call reality. It is part of the mechanism's function to make reality seem solid, spread out around us and looking as if it must have had a beginning far back in time.

Now comes the crucial Tantrik operation. Having understood this new picture, we then have to 'turn around' and look back up into the place from which experienced reality is coming (*figs. 3, 4*). This is the difficult thing to do. It has to be prepared for and worked up to. And

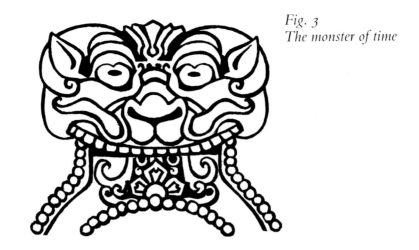

Fig. 3
The monster of time

Fig. 4
Shri yantra

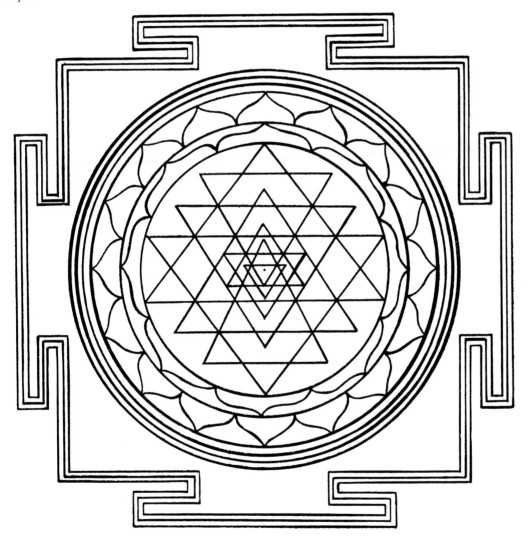

having done it, we have to go on living, fully aware of what is really going on. This backward look into the mouth which spews out time and space is represented in the great Tantrik yantra-diagrams, especially the Shri yantra (*fig. 4, plate 1*). The act of meditating on them is meant to drive the mind to take that backward look, in fact to reverse the act of Genesis, and stare straight into the continuing act of creation. All the Tantrik practices and art revolve around this process. The key word in Sanskrit is 'Paravritti', which means 'turning back up'. And the attitude of devotion or reverence, which expresses itself in the ritual of offerings and worship to symbolic images, is, at bottom, a way of keeping this possibility continuously in mind.

All outward expressions of such purely intuitive acts are bound to use special figurative and symbolic terms, which mean far more than they appear to at first sight. For ordinary words are made for ordinary situations and cannot express the extraordinary facts of Tantra. The chief symbol Tantra uses is sex. The act of continuous creation is expressed by patterns in sexual activity, which is seen as infused with a sense of totally transcendent love. The existence of the world is thought of as a continuous giving birth by the yoni (vulva) of the female principle resulting from a continuous infusion of the seed of the male, in sexual delight. The yoni is that rocket or monster-mouth spewing out the world; but at the same time there would be neither world nor yoni without the seed, which gives to the whole system its possibility of existence, its Being, which is always implicit, but can never be an object of perception.

Tantra supposes also that the seed itself generates the yoni. The seed may be symbolized in the Shri yantra by a central dot, the original point of energy which 'has location but no magnitude', usually depicted as white; it makes its fundamental originating movement in the shape of a female, downward-pointing triangle, which is red. From this original couple, the white and the red, evolves a series of interwoven triangles, four male (upward-pointing) and four more female (down-ward-pointing). Their interpenetration produces circuits of lesser triangles, which represent the sub-dividing of the original creative energies into more definite forces. The outer circles and rings of lotus petals symbolize the unfolded reality of the world. All the different phases of the creative process seem to exist at once, since we are looking backwards, beyond the flow of passing time.

An important point is that the creative act the Shri yantra symbolizes only produces 'things', those apparently solid objects we know, at the lowest stage of evolution. Tantra holds that our impression that things exist outside ourselves is really the result of an encounter between fields of energy. A rainbow only appears when sunrays, atmospheric processes and the optical activity of an observer come together in a certain relationship in space and time. In Tantra's understanding all other objects, no matter how dense they may seem, like rocks, planets and men, are so intimately interwoven with men's ideas of them as to be inseparable. They result in the same way from the collision and collusion of forces. And such forces can only be defined in terms of time; they are sub-functions of the processes of time. Tantra, in fact, calls its principal divine figures Mahakala (*plate 2*), the male Great Time, and Kali (*plate 3*), the female personification of Time. These two together are the creative functions of the unimaginable Brahman, the Parasamvit, the Supreme Truth, which encloses and projects all that can possibly exist throughout universes and star-systems 'numberless as the sand grains in the Ganges'.

The process of creation we humans know is symbolized in Tantra by many icons. These play a part in the rituals, and are called by the generic name 'yantra', which means any physical form which can carry a charge of symbolism. Yantras receive 'worship'; that is to say, they focus the imagination and emotions of the Tantrika, and identify for him phases of Genesis in Time. Most of them employ sexual symbolism, and many use human-shaped imagery. This is because the human body can be made to convey, through the qualities its shapes are given, its gestures and expressions, intuitions of inner states with which Tantrikas, male and female, can identify. If we recognize that all our universes in time emerge through psychosomatic forces, then we can symbolize these forces by images of men and women possessed by them. But Tantra art also uses a variety of extremely rarefied diagrammatic yantras (*plates 4–6*). It would be easy to call these abstract; this, however, would be wrong. These symbols refer to something denser and *more* real than the everyday world; they convey energy-realities which are so inclusive and emotion-ally exciting as to go far beyond the limits of any ordinary object we can recognize from everyday human experience. The Shri yantra is the greatest and most complex of these. It has many subdivisions, and lesser diagrams may particularize and present its component forces. All, however, are seen as at once active and essentially feminine.

The diagram illustrates some of the chief icons in Tantra, arranged in progressive series from left to right. At the top is the lingam, the male organ, symbol of the male seed of Being. In creative act it is represented as encircled by a symbol for the yoni, the female vulva, organ for the generation of world and time. Seen in plan view, the central shaft may become a circle or a dot, enclosed either in a vulva shape or a female triangle. Another image represents the lingam in an egg-like shape, with red flashes appearing on its surface (*plate 9*). This is the first stage of differentiation towards the creation of extended time (*plate 8*).

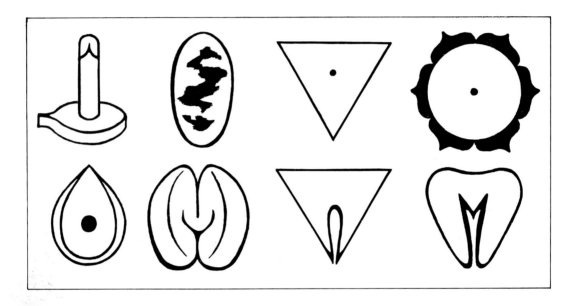

Fig. 5 Stylized symbols based on the female genital organs, with and without the male

From the purely human point of view, Tantra recognizes that human beings are in one way closest to the female aspect of creation. The male may seem, in a sense, inconceivable and remote, whereas the female, the Goddess of Time, is continually producing through us and for us; wherever we turn we meet her at work generating us as time-bound beings. Therefore, Tantra focuses its attention and meditation on the female as the most direct approach to the intuition of truth. It uses many female icons, including lotus-flowers, the strange natural form of the coco-de-mer which resembles the female genitals (*plate 12*), caves and natural clefts or hollows in stones and trees, downward-pointing triangles, and representational images of the female vulva itself (*plates 7, 10–11*).

But most often it centres its adoration on an image of the Goddess, in wood, stone, metal or dough, which represents her as a beautiful girl who, as she dances crazy with love, lets down her hair, spreading out the worlds, and binds it up again, bringing them to their end. The Tantrika's mind is continually absorbed in that shining and fascinating image. Every woman appears to him clothed in it. But it is not, for him, the woman who personifies the Goddess, but the Goddess who appears in the woman. The charm of the inner image is for him far greater than that of any actual woman; and the justification for every art-made icon of the Goddess used in Tantrik worship is that it promotes the intensity of that inner image, while at the same time it can never imprison the mind within its own merely material forms. Women, therefore, play a crucial role in Tantra. They are carriers of that female energy which occupies the central place in Tantrik imagery, and in ritual practice it is only by co-operation with women that the male Tantrika can progress. Man and woman must continually fulfil and complete each other. Only after long experience of mutual exchange can either alone carry out complete Tantrik rituals. Nevertheless, every ordinary human act of love is, in fact, a shadow of the cosmic art, and the more completely it is carried out the closer it may come to the divine primal act.

The loving Goddess of Creation has another face. As she brings man into time and his world, she also removes him from it. So she is his destroyer as well. All those things which cripple and kill—disease, famine, violence and war—are an inevitable part of her activity, seen from the viewpoint of man as victim. No-one can be a successful Tantrika unless he has faced up to this reality, and assimilated it into his image of the nature of the Goddess. Many Tantrik icons therefore show her as the black-faced and terrible Kali, her tongue lolling and her fanged mouth dribbling blood (*plate 15*). She may be hideous, but she must be no less loved.

There are many rituals, some of them sexual, carried out among the corpses in real (or symbolic) cremation-grounds, which bring this necessity forcibly home to the practising Tantrika. There, in the red light of funeral pyres, as jackals and crows scatter and crunch the bones, he confronts the dissolution of all he holds dear in life.

The creative process can be illustrated differently. The Shri yantra observes it head-on, in plan view; but it is also possible to consider it in side-elevation, so to speak, as a descent from the state of completeness.

This is a more philosophical and conceptual view, because to adopt it we need to take an imaginary step back to see the process as if it were separate from ourselves, which it is not. But as Tantra's philosophy is never merely abstract, it states even these philosophical propositions in terms of human and erotic symbolism which keeps them directly in touch with human experience. At the summit of the diagram (*fig. 6*), within the arch, above the pair of eyes, are the male and female principles, which are called Shiva (male) and Shakti (female energy). The latter has been projected from the former as the first stage of creation (*cf. plate 19*). The image is analogous to the dot and downward-pointing triangle of yantra diagrams (*fig. 4, plate 1*). The pair are so closely embraced that neither is fully aware of the other as distinct; and Shiva, the principle of self and complete identity, dominates. Shakti is said still to 'have her eyes closed', in total bliss, because she has not awoken to the state of separateness. The couple below those eyes (which will be explained later) illustrate the next phase. Here Shakti's eyes have opened, though the couple are still united. She is now in the first state of realized separation. The Shiva-self, the subject, has been 'presented' (actually has presented himself) with a separate active object, a 'that' distinct from his 'I'. The two face each other; but the fact is that this separation, and the separations which follow, are all the work of Shakti, who was projected expressly for this purpose.

At the next stage down the couple move out of union into distinct parts. Only their mutual sexual attraction reminds them that they belong to each other, that self and world are really only complementary aspects of the same reality. And now Shakti can really begin to function. She becomes in the next lower stage that beautiful female dancer, whose dance weaves the fabric of the world. The patterns of the dance are not pure illusion, but neither are they 'real' in the sense of being independent concrete facts. The self is so fascinated by her performance that it believes it is seeing all kinds of different things which are really *her* movements and gestures. Most important of all, it begins to think—because of her bewildering activity—that it is itself not one, but many, male and female. The bewildering array of an infinity of separate facts which composes the objective universe and at which we grasp, is presented to our self through what we call our mind and body, the psychosomatic mechanism in which each of our separated selves seems to be isolated and imprisoned. That, too, is part of the activity of the Goddess which, as we have seen,

Fig. 6 *The all-embracing whole of Reality*

Reality divided as the sexual pair,
Shiva and Shakti, within both man
and world, so deeply joined they are
unaware of their differences and
beyond Time

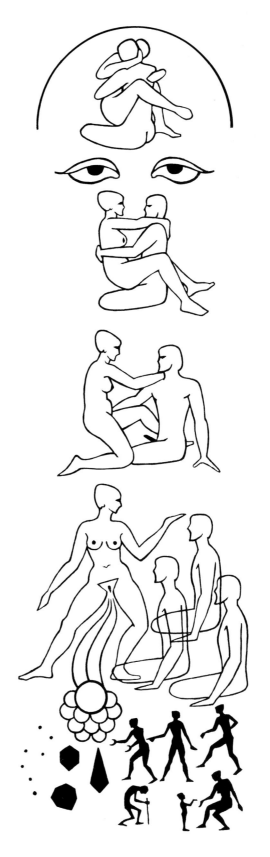

The sexual pair become aware of
their distinction

The female 'objective' separates
from the male 'subject'

The female 'objective' performs Her
dance of illusion, persuading the
male 'subject' he is not one but many,
and generating from Her womb the
world of multiplied objects in what
seems to be a sequence in time

'Subjects' perceive a differentiated
reality, seeming to be composed of
separate particles of objective fact,
and live lives that seem to be
extended in time

can also by symbolized by her fertile womb. All the things which we imagine we experience in time, the whole course of our individual life through our immense universe, is generated for us by that dance or through that womb which, if only we knew it, is not different from us. All our mental faculties and sense organs, with all the qualities they perceive and co-ordinate, are channels for that energy working towards separation and distinction, which Shakti represents. Philosophically such a doctrine is the most thoroughgoing holistic view, which pushes to its conclusion the ideas towards which many of our sciences are groping: that wholes are not compounds of lesser units—limbs, organs, elements and atoms—but that wholes come first and generate their parts. All causes lie in wholes, not in the accidental relationships between inferior parts. If time is included into the holistic picture, the meaning of the ultimate whole becomes virtually a definition of Tantrik enlightenment.

The diagram (*fig. 6, p. 19*) presented the Tantrik mechanism of Genesis. It is by working it in reverse order that we can climb back up towards the condition of knowing the Whole Truth. The vital link is the human body, with its senses and worlds of experience. For all the various stages represented in the diagram are correlated with groups of the body's own faculties. One can therefore say that, figuratively speaking, the whole universe is contained within the human body. But this is something that can only be realized in a special flash of intuition. Indian tradition has described many occasions on which some divinity has shown him or herself to followers as containing all the stars, universes, worlds, and creatures down to the minutest, within his body. It is a subject often represented in Tantra art, especially with Krishna as the divinity (*plates 23, 48*). But this truth is basic even on the ordinary human scale.

Indian tradition has always visualized the human body as growing like a plant from the 'ground' of the Beyond, the Supreme Brahman, the Truth (*plate 21*). And just as the vital juices of a plant are carried up and outwards from the root through channels and veins, so are the creative energies in the human body. Only the root of the human plant is not below, but above, beyond the top of the skull over the spine. The nourishing and bewildering energy flows in from the Beyond at that point. After spreading along through the body's channels it flows to the outermost tips of the senses, and even further out, to project the space around it which each body believes it inhabits. The pattern of

veins and channels which compose this system is called the 'subtle body' and is the basis of all Tantrik worship and yoga. The different levels of separation between Shiva and Shakti shown in the diagram on page 19 (*fig. 6*) are located at different levels in this body (*fig. 7*). That is the meaning of the eyes. They are each person's own. The arch is the dome of his skull where he is rooted in the Beyond.

Here, too, comes another important point. Most ordinary Indian traditions hold that the way to return to the wholeness of Truth is to repress ferociously, by asceticisms and will-power, all the faculties of the body and mind which participate in the process of projecting the mirage of separate persons inhabiting separate worlds. Tantra regards that sort of uphill struggle as absurd. Instead it says that *all* the faculties— the senses, the emotions and the intellect—should be encouraged and roused to their highest pitch, that the person's store of memories and responses can be awakened and re-converted into the pure energy from which they all originated. Feelings and pleasures thus become the raw material for transformation back into enlightenment. Needless to say, this is very difficult to do; and it is all too easy to fall into the trap of wasting creative energy in untransformed indulgence.

How is this re-conversion carried out? There are many overlapping techniques which can be used together. All involve manipulating various aspects of the imagery of Genesis; and all of them are grounded in reality, not fantasy. For example, sexual intercourse is used to reverse the process depicted in the diagram. Starting with a human partner who shares one's spiritual aims, one can go through a process of careful ritual which converts the ordinary man and woman back into personifications of Shiva and Shakti; and then their union is consummated. The sexual experience, enormously prolonged, is brought up through the stages to the point where the identity of each is blended with the others, and both experience the condition before the separation happened. It is an unparalleled joy, the joy of Being before and beyond Genesis. The image of the couple yogically seated in sexual intercourse is used in the Tantrik Buddhist art of Tibet as the universal symbol for spiritual fulfilment (*plate 42*).

The commonest technique of transformation adapts the everyday Indian custom of making offerings to an image. This has been so much misunderstood that it needs some explanation. Many of the things illustrated here are images meant to receive that kind of worship. In the

act of offering the Tantrika identifies his or her own self with the image, focusing that self upon it. The things offered—flowers, lights, bells, incense, food—are symbols for the senses. One washes the image, touches it with coloured powder and garlands it with flowers as if it were an honoured guest. One cannot, of course, be worshipping a mere object: it is the *meaning* one is welcoming into one's home and into oneself. In the course of a long ritual a Tantrika may set up and worship with offerings a whole succession of different but related images, one of which may even be a live girl into whom the original 'whole' of the Goddess descends. Others may be diagrammatic yantras, mentioned earlier (*p. 15, plate 30*). Some images are in permanent materials; others are made of mud or paper, to be destroyed after use, so preventing any mistake about the non-objective nature of the true meaning of the icon. But it is often felt that images gain in power and value by being used in worship either for long periods or by especially highly developed Tantrik masters.

One of the most important features of Tantra is its use of 'mantras'. These are syllables, single or strung together, most of them without obvious meaning. They end in a nasal humming sound represented by ṁ, sometimes in k or ṭ. (A few older mantras do actually have some meaning as words.) One important Tantrik mantra is 'Oṁ Klīṁ Strīṁ', but there are hundreds. They are meant to be the seed-forms of particular energies known to the Tantrika, but not identified with any worldly objects, though they may be identified with functional deities. They are used continually throughout Tantrik ritual, whispered or chanted in different combinations and contexts, setting up patterns of vibration that condense the energies they represent into that place and time. One must learn both to speak them properly, and to activate their meanings. They may be written in Sanskrit letters on ritual objects, or in the spaces of yantra-diagrams, or painted to be yantras themselves; they may be stamped on one's body or visualized in the air. They are felt to fill the space and time around the Tantrika with nuclei of energy which he is able to control. They are also the subtle forms of those fields of energy whose interference-patterns produce in the human consciousness the apparition of things in a world. For such a conception of 'fields of energy' is central and fundamental to all Tantrik activity, and the sacred Sanskrit alphabet, in which the names for all things may be written, is itself the reservoir of all mantras (*plate 28*).

Yoga is another most important technique of transformation. India knows many kinds of yoga; but the yoga used in Tantra is based more or less on Hatha yoga, with an extra dimension. The bodily attitudes, contractions and pressures which make up Hatha yoga are devised expressly to work upon the inner mechanism of the subtle human body, which will be described later on. And, needless to say, to perform Hatha yoga without doing any inner work on the subtle body is a pointless exercise from the point of view of Tantra, though it may help the outer body's health and stamina. Anyone who does any Hatha yoga, or knows its texts, will easily recognize the relationship between its pulls, twists, contractions and pressures and the various centres of the subtle body. But the extra dimension in Tantrik yoga comes from the bodily actions which are performed during sexual intercourse (*plate 33*). These are meant both to enhance the physical sensations and to transform them into a vehicle for blissful insight. They are learned only in practice with a sexual partner, under the guidance of a teacher; though in fact one partner may be the teacher, very often the woman.

This brings us to a most interesting point about Tantra. It records innumerable legends about the way its most famous male saints were initiated; in these the central episode is usually a ritual sexual intercourse with a female 'power-holder', whose favours the initiate has to win (*plate 64*). This may well be one of the most ancient elements in Tantra, since the idea that not only initiation, but the very capacity to reach the Tantrik goal can only be transmitted along a line of female 'power-holders' probably has roots in the oldest strata of human religion. Recent Indian religions are all strongly male-orientated; and many of the more conventional interpretations of Tantra, in texts which have been screened by Brahmin or Buddhist interpreters, tend to play down this central importance of the female. But history is full of examples of actual Tantrik saints, poets and sages who made much of their sexual relationship with a particular woman whose charms aroused them strongly, and who became for them prime agents in their enlightenment. Such women were usually of low caste; they might also be promiscuous practitioners of sexual intercourse and ritual, such as temple dancers or family prostitutes. Contact with one would be, according to Indian notions of caste purity, defiling, and place the Tantrika beyond the bounds of respectable society. This was always intentional. For Tantra demands that every bond with the everyday conventional world must be broken

if one is to obtain enlightenment; and the idea of oneself as 'good and respectable' is one of the most dangerously insidious of such bonds. To practise Tantra is to live in social exile from non-Tantrik society.

The most powerful sexual rite of re-integration requires intercourse with the female partner when she is menstruating, and her 'red' sexual energy is at its peak. Best of all is for this rite to be carried out in a cremation ground among the corpses and flaming pyres. For these reasons the representations in art of the female counterpart or initiator are usually coloured red. Traditions differ on another point. Some, probably the representatives of the oldest strand of thought, accept that the white male seed should ultimately be ejaculated into the woman's responding yoni, as if it were an offering of sacred oil being poured into an altar fire; the genuine physical orgasms of both partners are thus transformed and consumed in the far greater ecstasy induced by elaborate yogic practices. Other traditions, more orthodox in the Indian sense, say that orgasms must be totally inhibited, and the energy which would have been expended in them should be turned back and totally sublimated into a radiant inner condition.

The most famous Tantrik rites are the variants of the chakrapuja. This is a kind of long-drawn Eucharist, carried out by night, attended by a number of couples, married or not, who ceremonially take the five enjoyments normally forbidden in high-caste society: meat, alcohol, fish, a certain grain, and sexual intercourse (*plate 35*). The last may be performed with several different partners, one's own, or one chosen at random. Again, it is a question of arousing and controlling extraordinary energies. And it should be mentioned that one of the most ancient and powerful symbols for cosmically creative and sexual energy, which figures in many Tantrik works of art, is the snake (*plates 39, 40*).

All this helps to explain what lies behind the description of the happy Tantrika given earlier (*p. 9*). But one special feature still needs explaining — the music and art. In fact, Tantra is the one strand in Indian tradition which has included purely aesthetic experience into its religious scheme. There are, of course, many branches of non-Tantrik Indian art; but Tantra cultivates artistic experience *for its own sake*, holding that all the body's stored-up responses, sensuous, emotional and intellectual which art is capable of arousing are fuel for the Tantrik flame. Indian art is anyway profoundly sensuous, and Tantra harnesses the stimulating beauties of erotic temple sculpture (*plate 36*) and Rajput Krishna mini-

ature-painting (*plates 45–7*) to its own ends. Indeed, there are Tantrik texts devoted to the beautiful incarnate god Krishna, the blue-skinned cowherd with whom all the women of his tribe, especially Radha, fell hopelessly in love. Indian poetry, song and art always dwell lingeringly on the physical details and colours of their passion. But Tantra takes them as fascinating instruments of the great Goddess, who uses this projection of herself into Krishna and Radha to transmit a reflection of the experience of cosmic ecstasy to those who favour the way of positive love, or whose interest inclines them to art and music.

The central conception inspiring the whole of Tantra is that of the subtle body, the mechanism of energies which we have already seen actively creating the world during the process of Genesis. Methods of reversing the process have been mentioned earlier. But the lines upon which they all work are laid down in the structure of the inner body, which can be represented by a detailed chart of the knots and currents which flow through the human psychosomatic organism. There is one question that everyone naturally asks: is this subtle body to be thought of as 'real'? The Tantrik answer is: if by real you mean belonging to the world of objective outer facts, no; it is 'upstream' of all such facts, and in an important sense more real than they. But it is discovered only as inner experience, like the taste of a lemon, by anyone who makes even a modest effort to focus his attention inward. Unless one is communicating with a person who has this experience, one can only talk of the inner body vaguely and schematically; this is all we can do here.

Since they are dealing with an impalpable inner experience, the descriptions given in different texts vary slightly. Hindu and Buddhist Tantra agree in principle on the pattern of this subtle body, but differ in some respects, which are less important than they may seem at first. In Nepal, during the last few centuries, Hindu and Buddhist traditions were happily combined. The Tantrika who sits down to carry out his ritual and yoga begins by settling himself at the centre of his own world. He first visualizes the earth, with its continents and seas, as an immense plane disc—a mandala—spread out around a colossal central mountain pinnacle, the mythical Mount Meru, which resembles a high peak of the Himalaya. Around this disc he sets out the circling orbits of the planets and the apparently revolving constellations, perhaps visualizing them in the form of anthropomorphic deities. To him, the heavens, which provide our human reckonings of time, are a significant function of the

creative faculty in which he shares, and to survey them can lift his mind to a sense of the immensity of what he both worships and is. The Tantrika takes a deep interest in astronomy and astrology, and always studies time-charts of the significant events in his life. Many works of Tantrik art relate to this whole essential first phase of ceremonial, and provide the basis for the Tantrika's visualizations (*plates 4, 5, 32*).

In the next phase the Tantrika identifies the inner central column of his spine (called Sushumna) with the axis at the centre of Mount Meru, so that he experiences himself as the centre around which the whole circuit of his world revolves. Cosmos and man are identified; all individuals' centres are intrinsically the same. Armed with further diagrams he then sets himself to analyse that world into its component energies and to identify these as flowing out into it from his own sensuous and mental structure. He can focus them upon the lowest of the 'wheels' (chakras) or 'lotuses' in his subtle energy-body. Broadly their layout matches the pattern given on page 19.

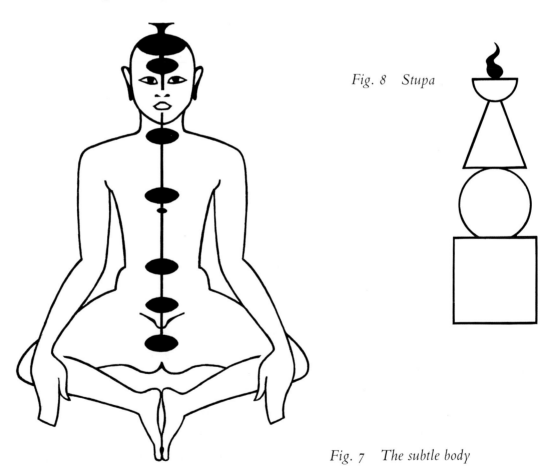

Fig. 8 Stupa

Fig. 7 The subtle body

A whole series of these lotuses is strung vertically up the shining filament of the central Sushumna (*fig. 7, plate 54*). All are mandalas of different types. The usual number is six, with a seventh at that critical root of existence in the top of the skull. Some traditions visualize more, towering beyond the head into different levels of the Beyond (*plate 55*). Another pair of subtle channels, male and female, 'sun' and 'moon', white and red, twine in a spiral around these lotuses, circulating energy. They are controlled by controlling the breath. The lowest lotus (with four petals) is at the base of the pelvis, in the perineum just in front of the anus. Hindu Tantra takes great interest in this one. For it locates there the subtle snake Kundalini who is each man's own Goddess-world-projecting function (*plate 54*). She sleeps, coiled around an inner lingam, covering its mouth with hers. Its mouth is the entry to the bottom end of the Sushumna, and her coilings are the source of world-experience. By yogic and sexual postures and pressures, having his world-disc within the circle of this lotus, the Tantrika 'awakens' Kundalini, who straightens, and pierces the bottom end of the Sushumna to begin her ascent. The initial sensation is violent and quite indescribable. There-after Kundalini enters each higher lotus in turn as the Tantrika focuses his mind on its structure and meaning.

The aim of the Hindu Tantrika is that his Kundalini shall ascend the Sushumna as often as possible, and in the end virtually permanently. The Buddhist Tantrika, whose Buddhism makes him reject sensuous imagery which may be too clear-cut and enthralling, nevertheless also visualizes an 'inner girl' who ascends his spinal column, and is represented in Buddhist Tantrik art by female figures such as the 'red Dakini' (*plate 64*). Both traditions describe how, near the summit, the female energy encounters the male seed of Being, uniting with it sexually (as shown in the diagram on page 19). From this union a supernatural nectar flows down to flood the body, while the whole man or woman becomes identified with the source of self and world which lies beyond the crown of the head. The achievement of the ascent may be symbolized by a great bird, equated with the mystical Persian Simurgh. This is sometimes shown in art as carrying a pair of divine lovers.

This is the broad pattern of the 'reversal' of Genesis. The ascent is elaborated in detail. All traditions accept that it passes up through the regions of the five elemental states of 'matter', each lower state being progressively absorbed into the higher: the solid is symbolized by earth;

the liquid by water; the incandescent by fire; the gaseous by air; while the etherial has no direct symbol. (These resemble the 'elements' of European alchemy, so often misunderstood.) Each higher state of 'matter' comes nearer to the condition of undifferentiated energy, and represents a more intense inner perception of the interfusion of forces as they dissolve in time. The series, represented in the diagram (*fig. 8*), is symbolized in the Tantrik Buddhist stupa (a symbolic shape derived from the domed mound near the summit of which the bodily relics of Buddhist saints were enshrined for public reverence). It may be any size from a huge building to a small brass object.

Hindu Tantra locates these elemental states as follows: the yellow solid state, square, is in the lowest lotus with four petals; the white liquid, circular, with six petals is at the level of the genitals; the red incandescent, triangular, with eight petals is at the navel; the green airy, semilunar, with twelve petals is at the heart; the greyish etherial, whisp-like, with sixteen petals is at the throat. Between the eyebrows the Hindus locate a white two-petalled lotus where the union of male and female is consummated; and from the crown of the head spreads the thousand-petalled lotus of the Bliss of the Beyond (*plate 59*), whose radiance is the sum of all possible colours. It is at the level of the navel, in the region of fire which is represented externally by the cremation ground, that our everyday time is transcended. Just beneath the heart is located another small lotus called the 'island of jewels', which is the place where the individual's sense of separate self is generated in the downward course of Genesis, and obliterated in his upward return to the source by meditative ritual.

Buddhist Tantra lays little stress on the lowest lotus, knows no Kundalini, and prefers to omit the lotus behind the genitals. It does, however, identify the ascending consciousness-energy with the sexual vitality, symbolizing it by the male semen, borne by the female figure. It focuses first on the lotus of fire at the navel, treating it, like Hindu Tantra, as the critical transformation stage; in it is an altar surrounded by flaming guardian deities, on which the self is immolated, like the dead body in the funeral pyre—a sight deeply familiar to every Indian.

But at the level of the heart Tantrik Buddhism envisages its most sweeping and characteristic set of fields of energies, far more elaborate than the heart-lotus in the Hindu system. The set is laid out in five circles within a vast flat disc (*plate 68*); four are at each of the main

directions of space—south, east, north, west—and the fifth is at the centre. Within each of these is a peaceful Buddha figure, of a symbolic colour who meditates in sexual union with his 'Wisdom', along with subsidiary figures. Each Buddha represents the state of being aware of all the mistaken views produced by a particular emotion and a particular deluding function of the mind. It is the female wisdom-state with whom he is united whose grace enables each Buddha to invert these emotions; and the meditator is supposed to identify himself with each Buddha successively, opening his mind, by grace of the appropriate Wisdom, to the full realization of what *they* realize. For according to Buddhist ideas one must not look for 'higher objects' like deities on which to fix one's mind; one must learn instead to live ultimately in a state in which all objects, even 'higher' ones, are abandoned as illusions, dissolved into an immense and seamless web of relations, in which there is neither space nor time.

A person meditates on and realizes each of the fields (*plate 68*) in a spiral order, south, east, north, west, absorbing one into the next. That at the east, the realm of 'anger', is especially important. For this 'emotion' somehow represents the root 'energy function' which carries the meditation forward; and the wrathful form called Vajrapani embodies the energy of the meditator's resolve to succeed. At the centre his consciousness-energy then moves up on the central Sushumna to the throat lotus, where there is a similar set of fields occupied by energetically dancing Knowledge-Holders, each corresponding to the Buddha below, and each in intercourse with a female counterpart. These fields again are passed through in spiral order, opening up new states of knowledge. From the centre once more the consciousness-energy rises to the highest circuit of fields, arranged on a similar plan. Here all the identification-images are seen as possessed by a violent passion, both wrathful and sexual, symbolizing the extremest state of aroused energy (*plates 62, 63*). After this series of states has been passed through, the mind becomes open to the entire range of possible vision, and passes, again via the centre, to the state of Supreme Knowledge; this is sometimes symbolized by a blue Buddha tranquilly seated in the sexual embrace of a pure white Wisdom, or by a golden couple (*plate 42*). This whole process may also be symbolized in sets of yantras in which shapes and colours rather than anthropomorphic figures are the medium.

The famous mantra of Tantrik Buddhism is 'Oṁ mani padme Hūṁ',

'Oṁ', is the sound of central enlightenment; 'mani padme' means 'jewel in the lotus' or 'male within the female organ', the state of completeness, energy infusing wisdom. 'Hūṁ' is the sound of power, forcing the mantra into realization. This energy is often symbolized by an implement called the vajra, double-ended with ornate curved prongs enclosing a central straight prong (*plate 47*). All Tantrik Buddhists own one, which serves each person as a reservoir of personal power. Vajrapani means 'he who holds the vajra'. And to help forward his meditation the Tantrik monk may also use a bell, whose rim he gently and continuously rubs with a stick so as to produce a sustained, gentle and entrancing hum.

This sound is the symbol for the remotest expression of the subtlest Tantrik truth. It is the audible form of the most ancient and potent Indian mantra, 'Oṁ' itself. For Tantra, like all good science, recognizes that the fabric of even the densest-seeming objects is of an order related to vibration, which is symbolized for the human intelligence by sound. And the rhythmic functions—heartbeat, breath, cell-change—structure each animal's sense of time and life. The differences and interactions between material things as experienced, have their roots in the inter-ference-patterns produced among combined frequencies of vibration. In these again we can recognize the vast fields of activity of the creative Goddess. Oṁ is the utterance which, correctly used, can unite and harmonize them all. The Tantrika may find in it the consummation of his meditative and devotional activity, his sexual yoga and mantra-practice. He may finally learn how to send the harmonizing 'Oṁ' resonating up the crystal cavity of his subtle spine, and open his whole body to that root energy, which will then flood in through the crown of his head from the Reality beyond time, the source of every Genesis.

To make this experience real and permanent, to live continuously aware of it, is the whole aim of Tantra.

The Plates

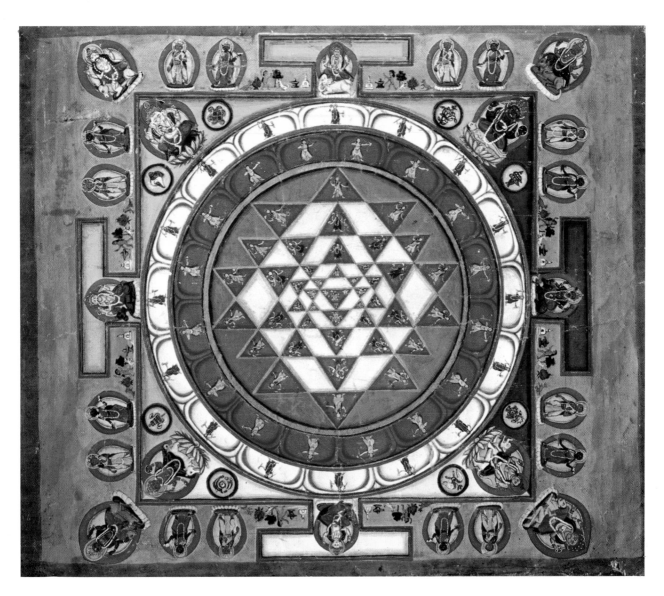

1 A Shri yantra, the most important of all Tantrik yantras. The outer triangles are occupied by divinities which represent the subdivided energy-self of the Great Goddess. Nepal, *c.* 1700. Gouache on cloth 20 × 24 in.

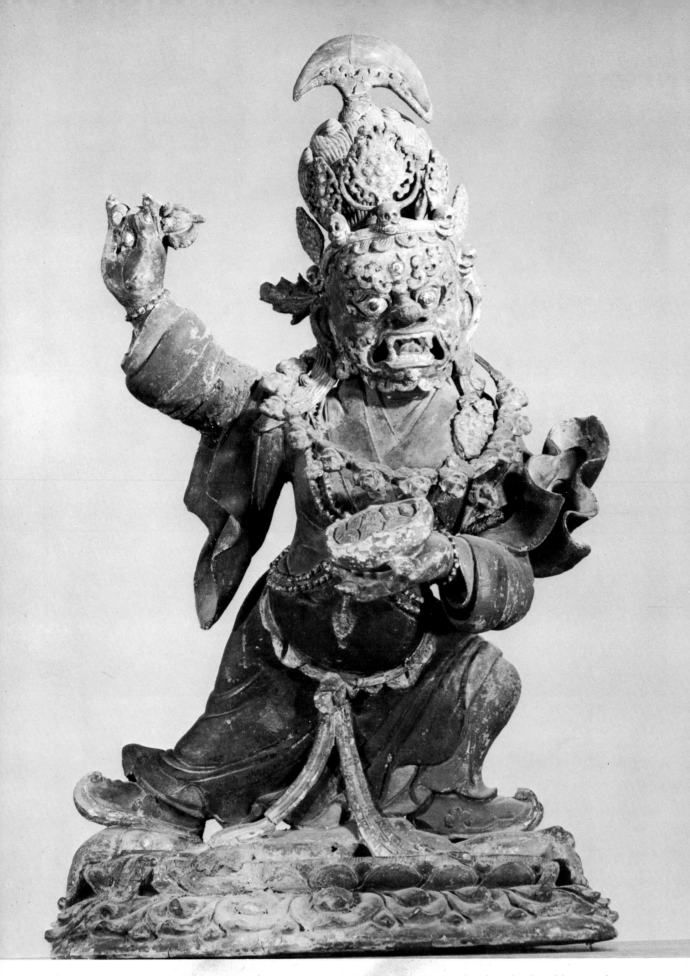

2 Mahakala, the Power of Devouring Time, with a flaying knife in his headdress and a skull-cup of blood in his hand. Tibet, 18th century. Painted terracotta, h. 25 in.
3 Kali, the female personification of Time, with skull headdress and a necklace and girdle of snakes. 12th century. From a temple in South India

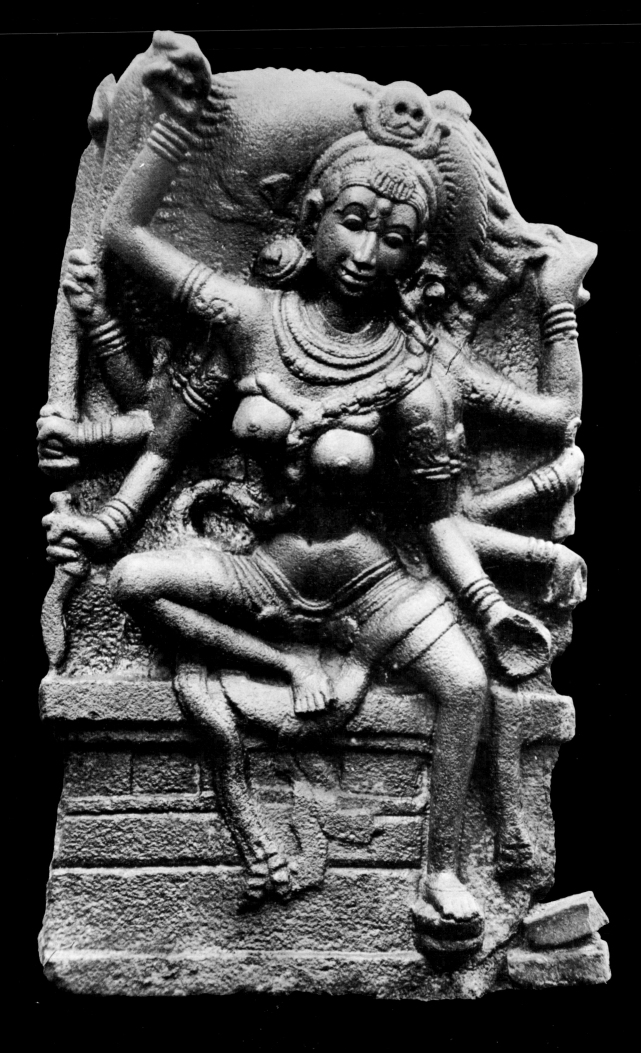

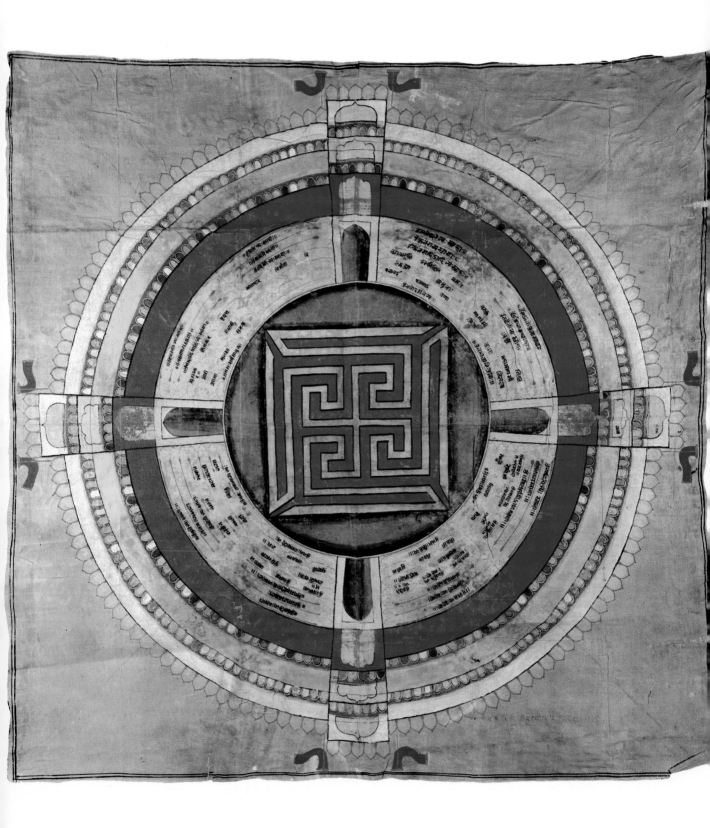

4 Jaina diagram of the cosmos, a 'swastika yantra', used for meditation. Rajasthan, late 18th century. Gouache on cloth 48 × 48 in.

5 Leaf used for the computation of time and the projection of mantras in series. Rajasthan, 18th century. Gouache on paper $4\frac{1}{2}$ × 10 in.

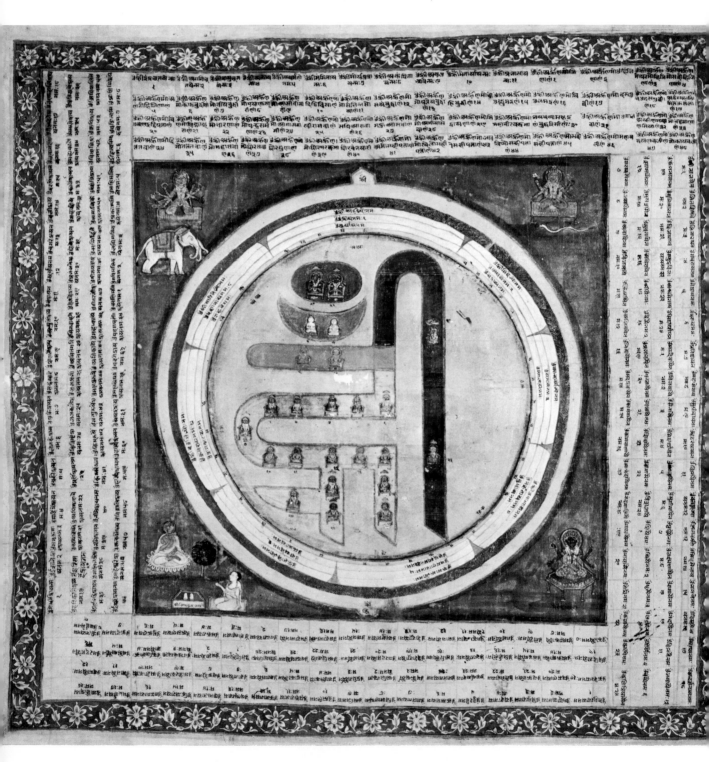

6 Oṁ yantra. The sound Oṁ is the most ancient and potent Indian mantra. Rajasthan, 18th century. Gouache on cloth 21 × 22 in.

7 Icon of the Divine Vulva, stained with the coloured powders used to worship it. South India, 19th century. Carved wood 8 × 7 in.

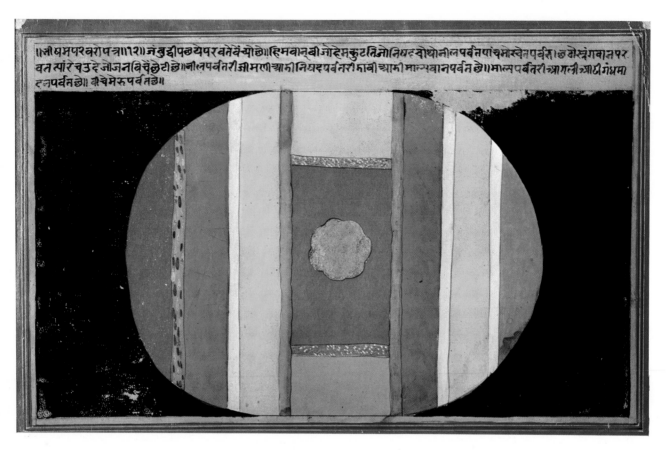

श्रीघसपरव्राप्रत्राा।२॥जंबुद्धीपछेयेपरवतेवेंयोछे॥हिमवानबीजोदेमकुटनिनोनिषदबोधोनीलपर्वतपांचमरुस्वेपर्वरा।छगोस्रेगवापर
वन यांरेचउदेजोजनविचेंछेटीछे॥नीलपर्वतरीजीमलीआंनीनिषदपर्वनरीहांबीआमीमान्खवानपर्वनछे॥मान्यपर्वतरीआगलीआंगलीआगंधमा
रनपर्वनछे॥वचमेरुपर्वनछे॥

8 The fertilized world-egg, dividing into regions and currents of energy.
Rajasthan, 18th century. Gouache on paper 11 × 17 in.

9 The Original Unity, represented by a stone shaped like an egg or lingam
(male organ). The natural red flashes on the surface represent female separating
energy. North India (Brahmaputra Valley), age unknown, h. 10 in.

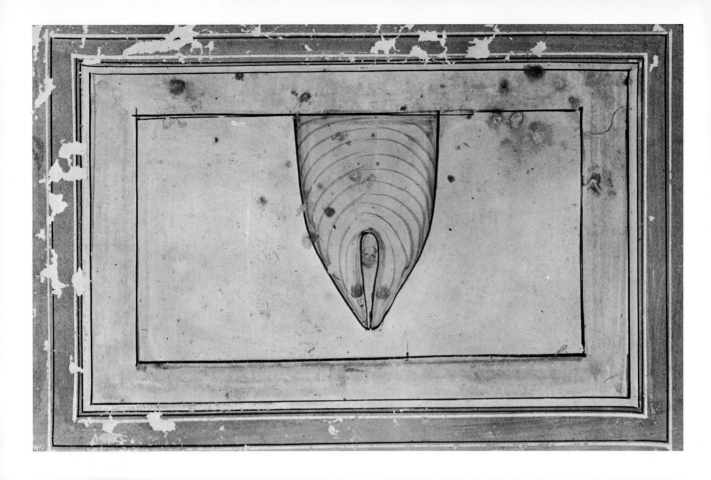

10 The Divine Vulva appearing in a constellation of stars. Rajasthan, 18th century. Gouache on paper 5 × 7 in.

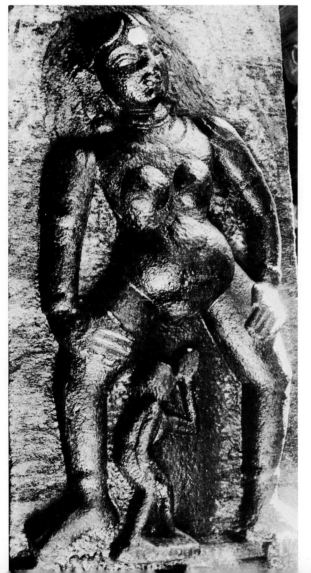

11 Tantrika adoring the vulva of the Great Goddess. A pillar sculpture from South India, 17th century

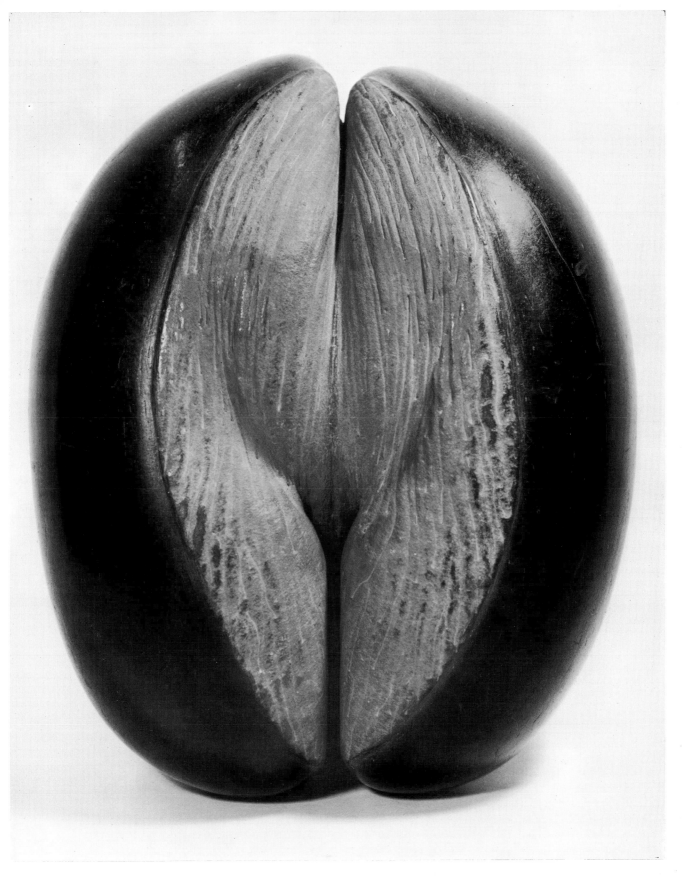

12 A coco-de-mer, worshipped as an emblem of the vulva of the Goddess.
South India, 19th century. Coconut shell h. 17 in.

13 Personification of the power of fire, from the corner of a gilt-bronze pedestal designed to hold a human skull cup. Nepal, 17th century.

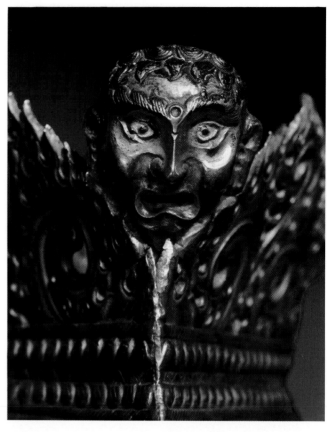

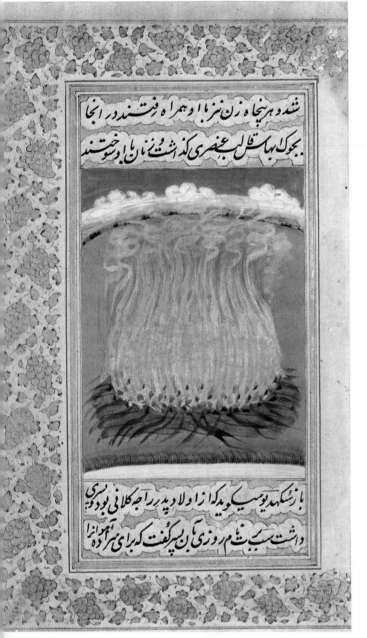

14 The principle of fire, representing death and cremation, and also the state of mind necessary for Tantra; a page from a manuscript of the Bhagavata Purana. Rajasthan, 17th century. Gouache on paper 9 × 6 in.
15 The Goddess Kali. Calcutta, 19th century. Water-colour on paper 18 × 11 in.

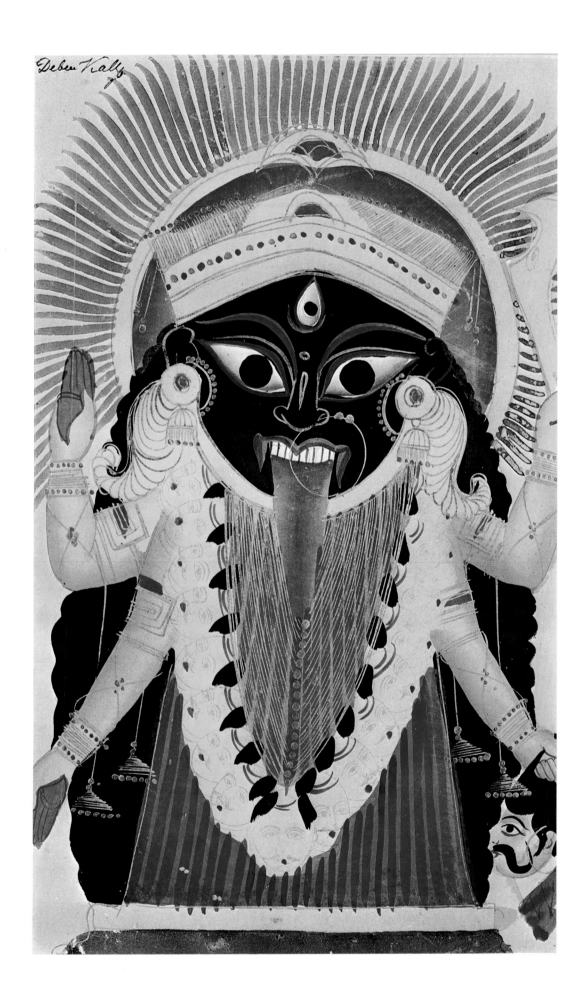

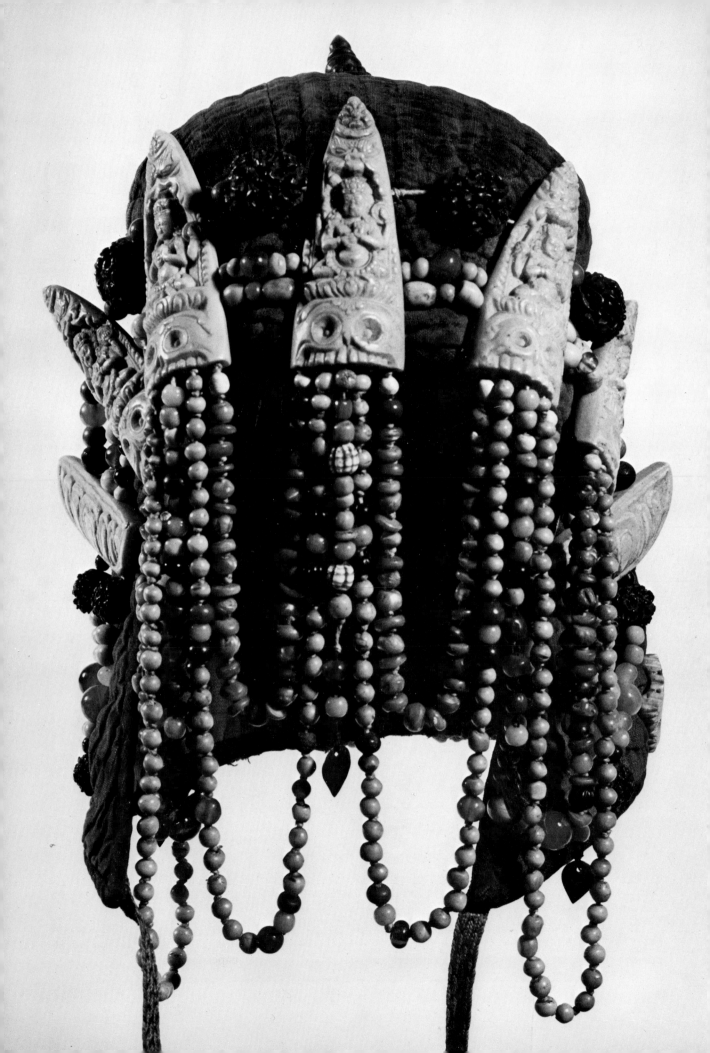

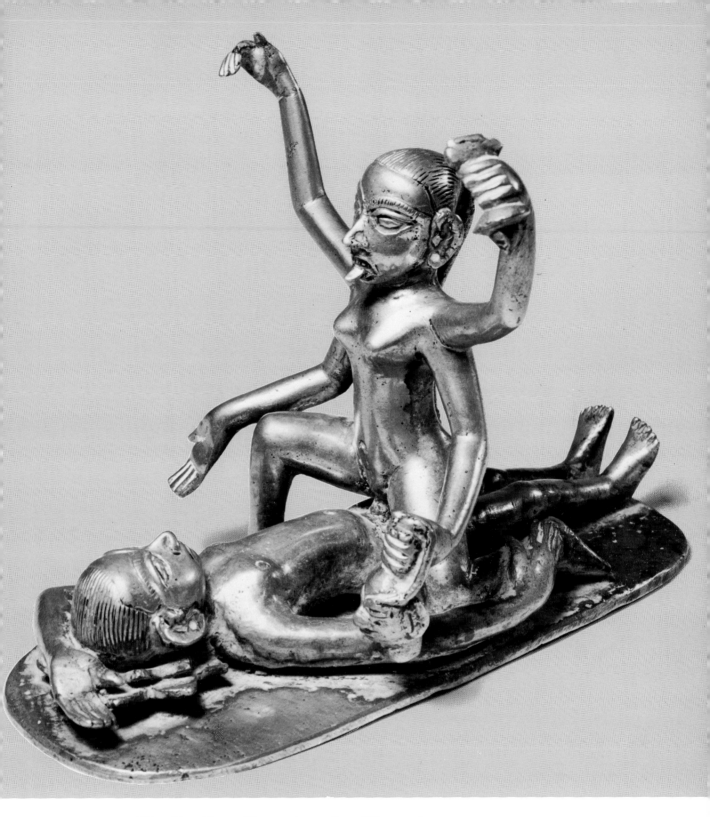

16 Ritual headdress of human bone, from Tibet. 19th century
17 Kali seated in intercourse with Shiva, the male principle, in his corpse-
form. Rajasthan, 18th century. Brass h. 5 in.

18 (*overleaf*) Kali seated in intercourse with the corpse-image of Shiva, Panjab,
18th century. Gouache on paper 9 × 6 in.
19 Shiva, the male principle, sitting with his wife on his left knee. They are
the original couple, and her projection from him formed the first step in the
whole creative process. Basohli style, 17th century. Gouache on paper 10 × 7 in.

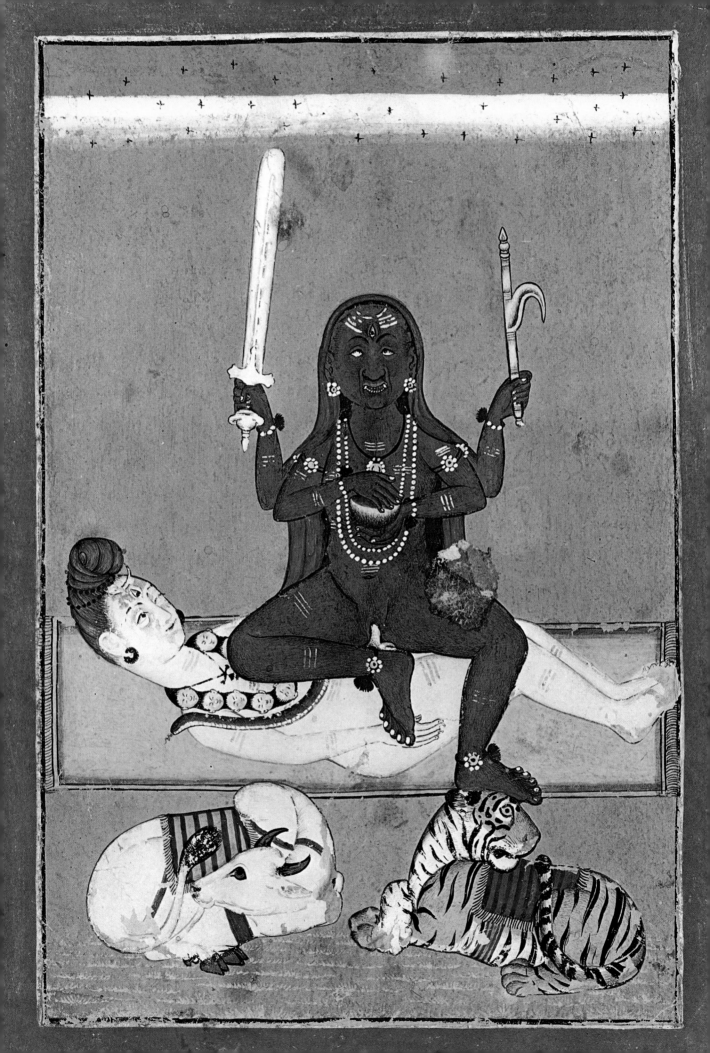

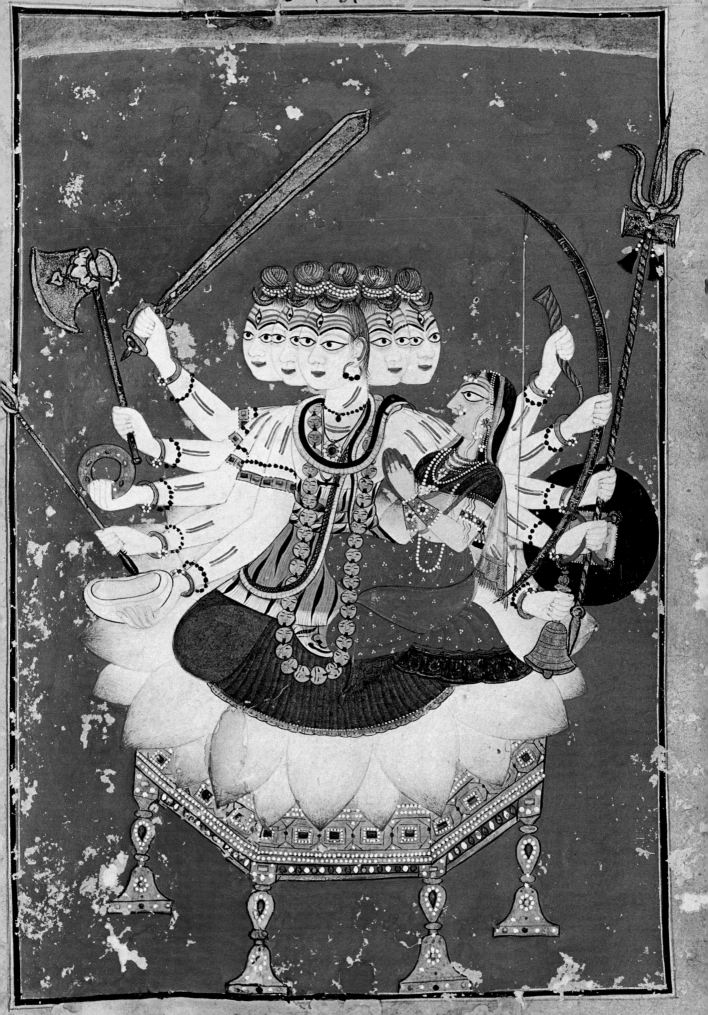

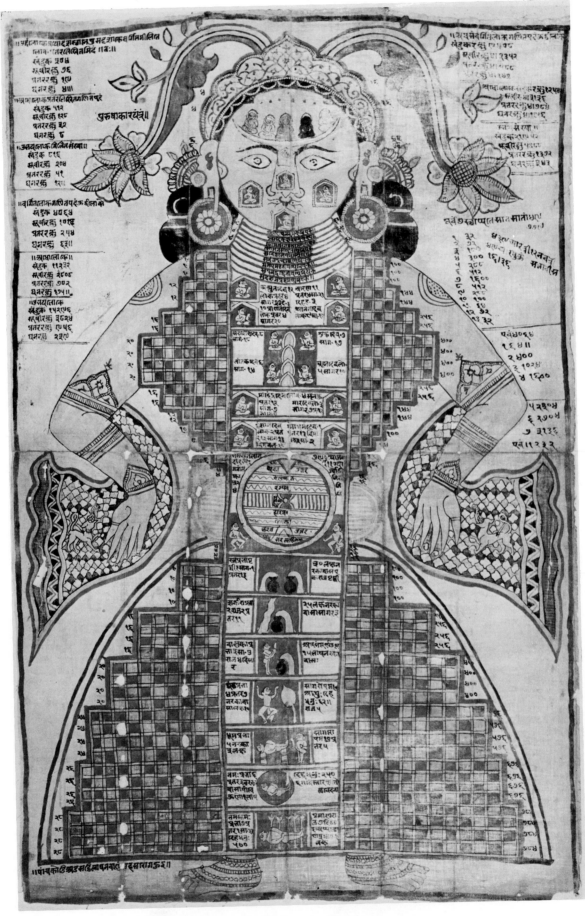

20 Jaina world-image in human form, containing all possible worlds and time.
Rajasthan, 18th century. Gouache on cloth 15 × 11 in.
21 The subtle body as a plant growing from the ground of the Beyond.
Rajasthan, 18th century. Inks on paper, 19 × 13 in.

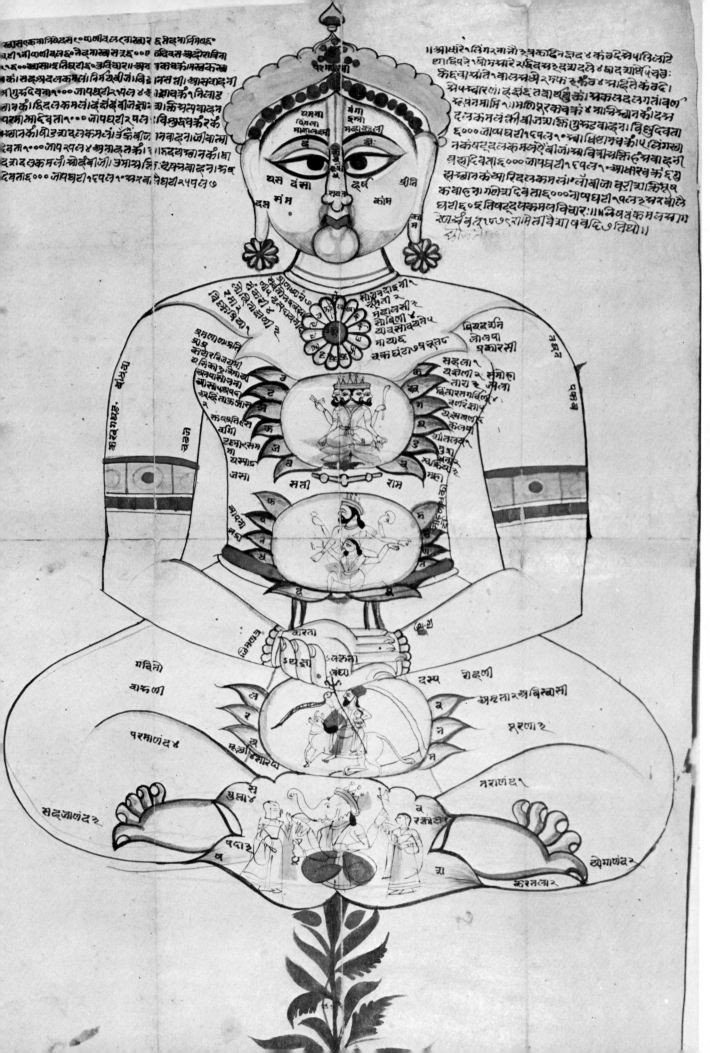

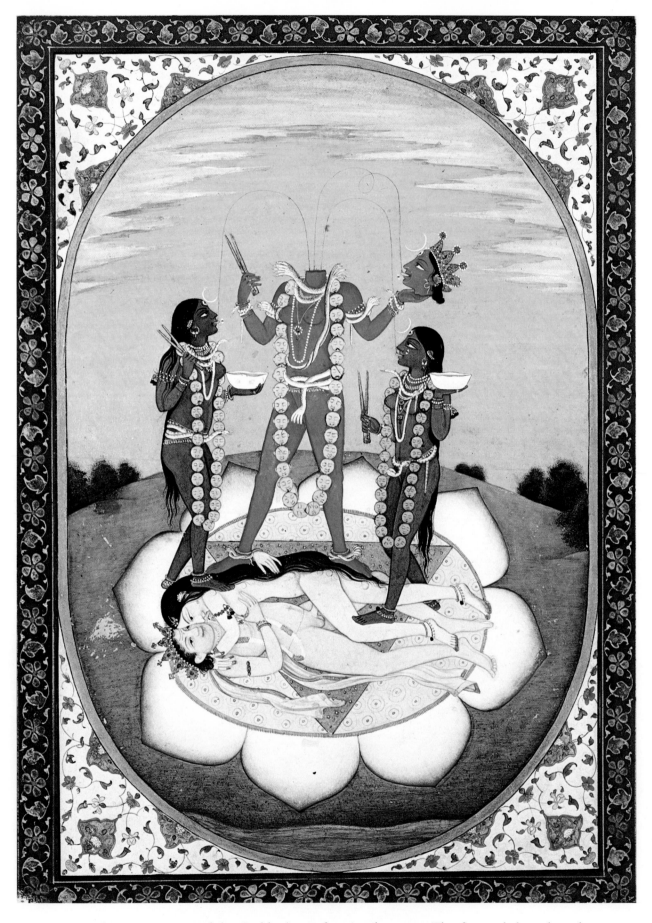

22 Chinnamasta, one of the Goddess's ten functional aspects. The figures below show her divine origin; above she severs her neck to nourish the parts of her separated self. Kangra, *c.* 1800. Gouache on paper 12 × 8 in.

23 The Universe as a Cosmic Man, with Vishnu at the base, Krishna and Radha at the top. Nepal, 17th century. Gouache on cloth 61 × 41 in.

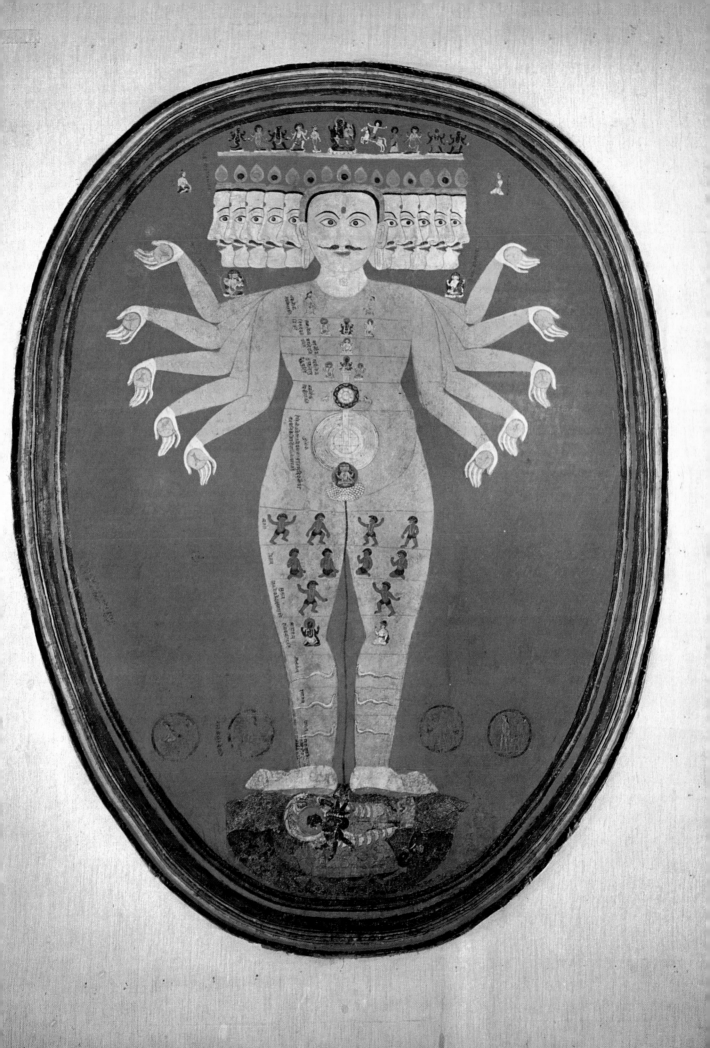

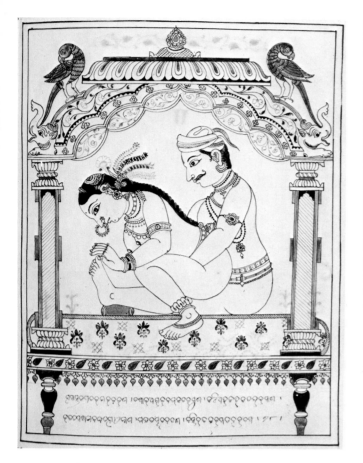
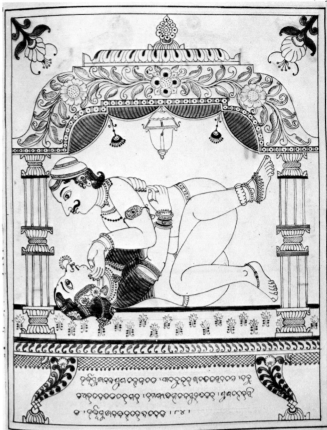
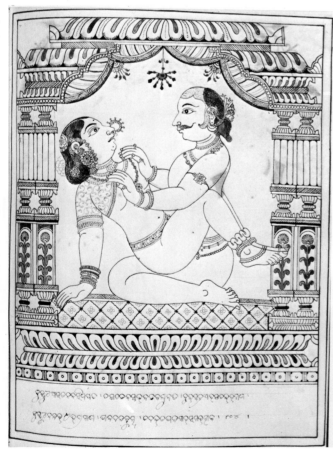
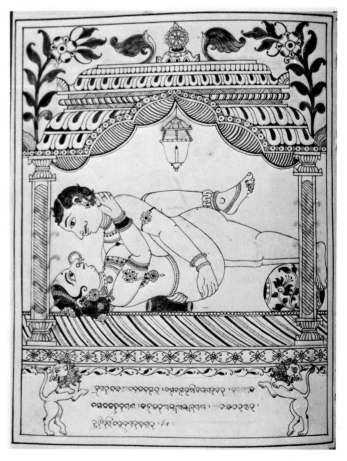

24–7 Sexual intercourse is the principal form of 'enjoyment' which Tantra harnesses to its spiritual ends. Postures of love which enhance its delight, a manuscript series from Orissa, 19th century.

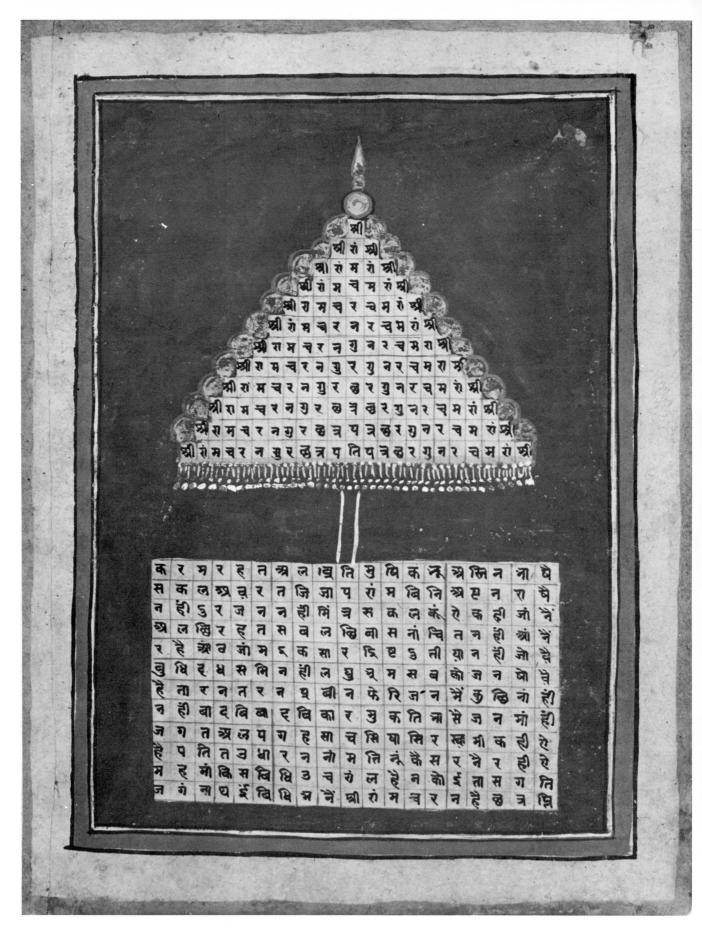

28 A sacred umbrella formed out of the Sanskrit alphabet, whose sounds are the dwelling place of the Goddess. Rajasthan, 19th century. Ink and gouache on paper 11 × 9 in.

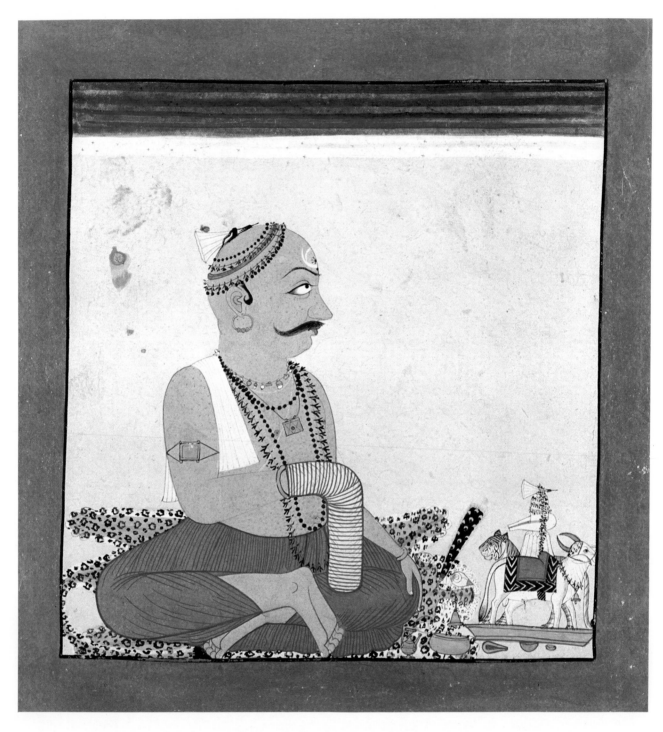

29 Raja performing worship in front of an icon, with a rosary-bag on his
hand. Mandi, *c.* 1720. Gouache on paper 8 × 8 in.

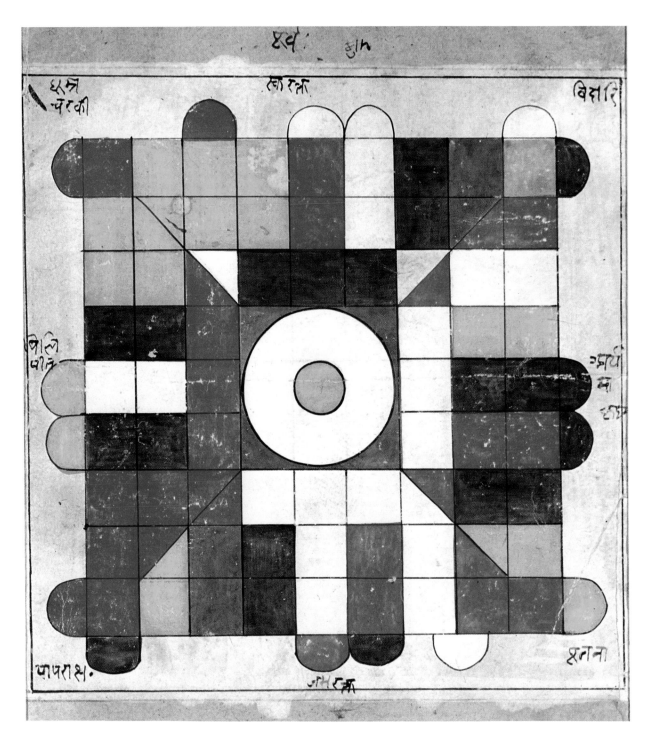

30 Diagram used in computing astronomical periods, which also serves for meditation. Kangra, Himachal Pradesh, 18th century. Ink and colour on paper 11 × 8 in.

31 The divinity in the ceremonial water-pot. Rajasthan, 19th century. Gouache on paper 9 × 9 in.

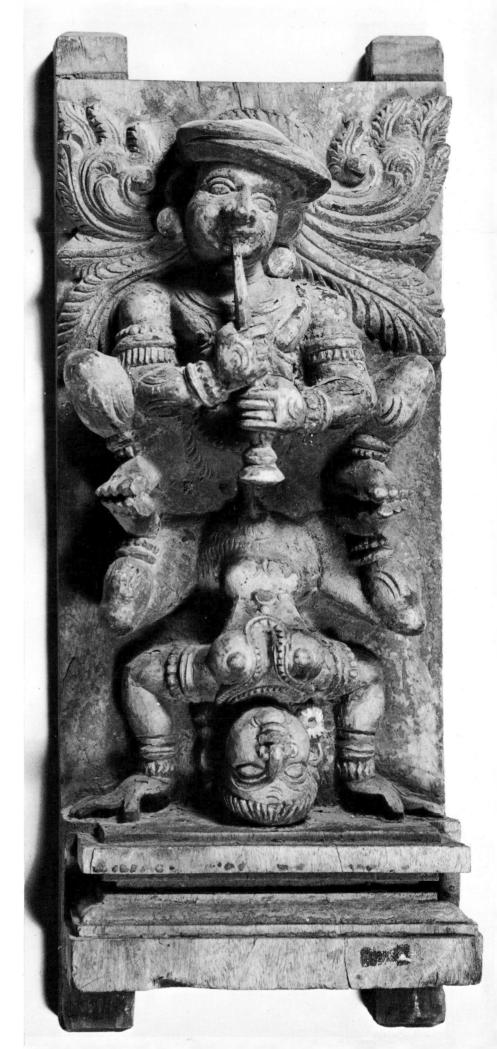

32 Celestial couple in sexual intercourse. South India, 18th century. Wood bracket panel from a temple car, h. 16 in.

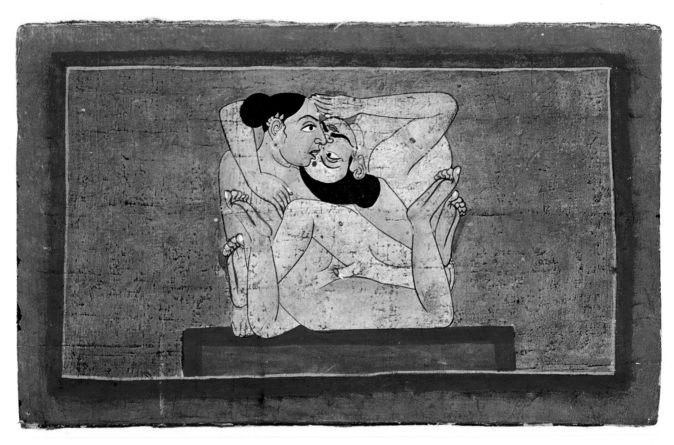

33 One of the yoga postures of sexual intercourse which enhance the process
of inward transfiguration. Nepal, 18th century. Gouache on paper 15 × 9 in.

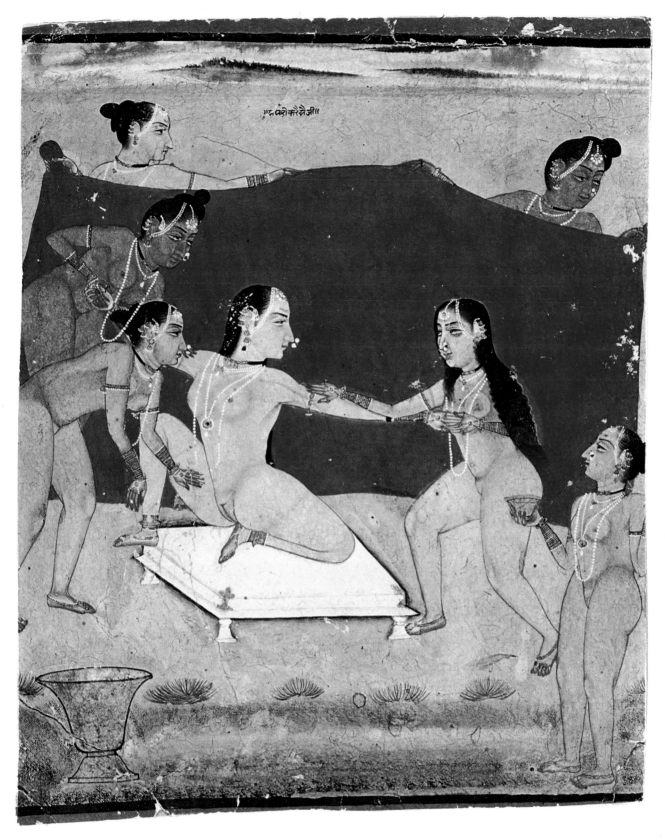

34 A noble Tantrik lady is anointed and massaged after bathing and before intercourse. Rajasthan, 18th century. Gouache on paper 9 × 7 in.

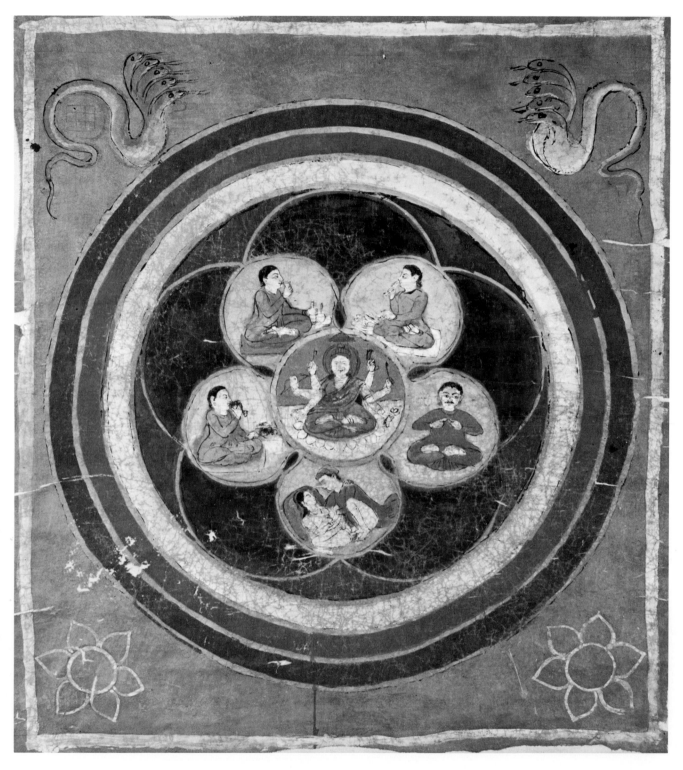

35 The five 'powerful enjoyments' (meat, alcohol, fish, a certain grain and sexual intercourse) as eucharist round a figure of the Guru. Rajasthan, 19th century. Gouache on cloth 35 × 33 in.

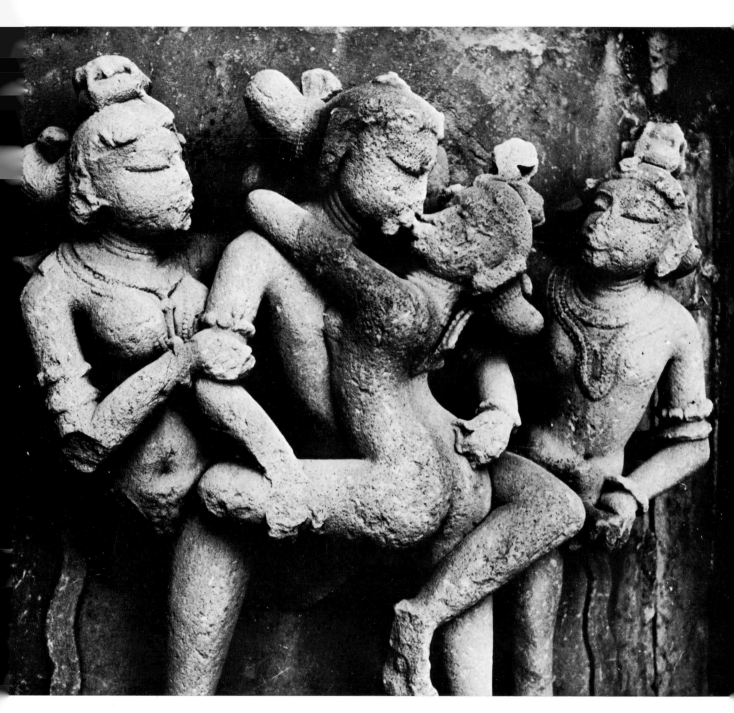

36 The erotic joys of heaven, depicted in medieval temple sculpture. From the 'heaven bands' of a temple at Khajuraho. *c.* AD 1000

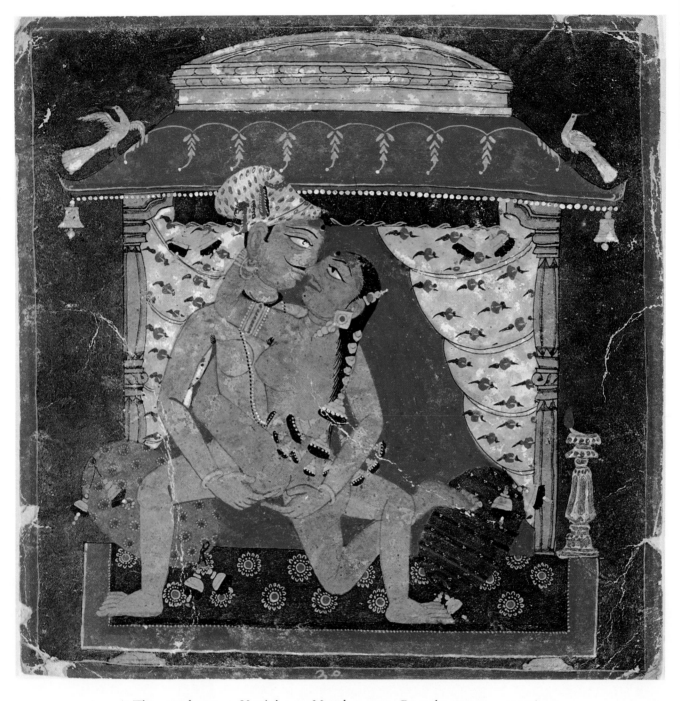

37 The sexual posture Yoni Asana. Nepal, *c.* 1700. Gouache on paper 7 × 7 in.

38 A prince and a lady making love, the basic Tantrik act at the human level. Kangra, 18th century. Gouache on paper 8 × 6 in.

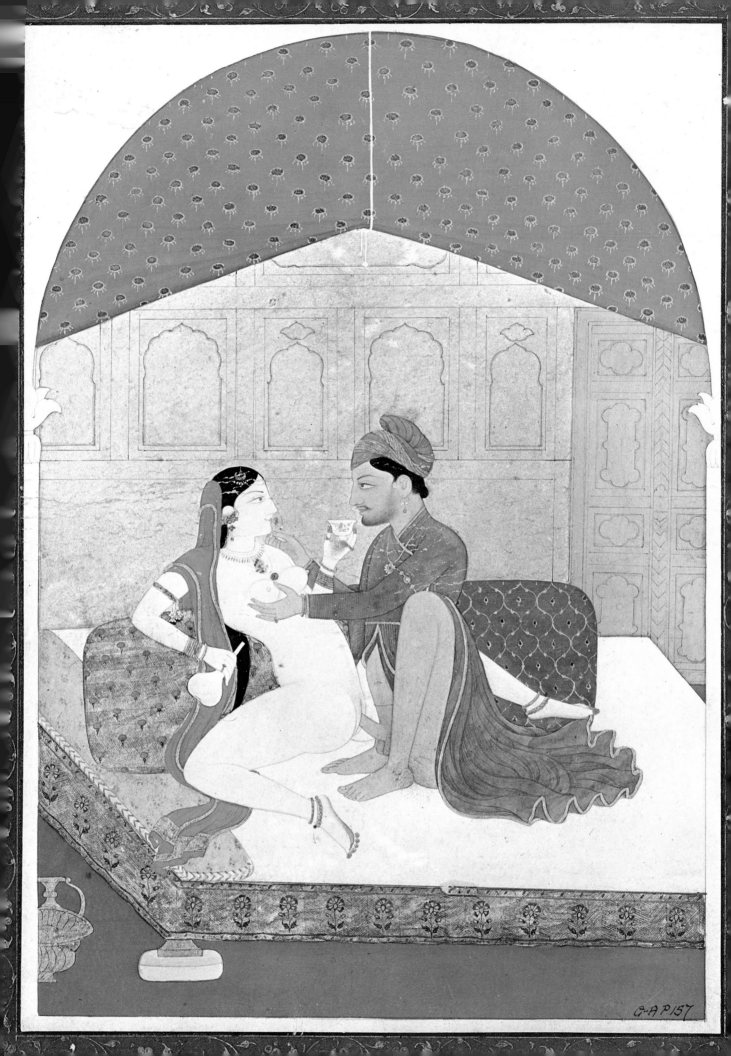

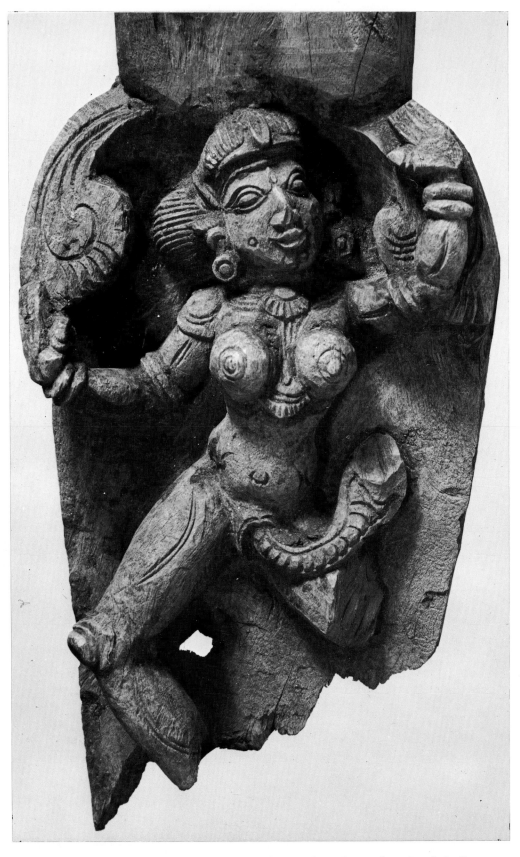

39 Yogini with serpentine energy manifesting from her vulva. South India
c. 1800. Wood h. 12 in.

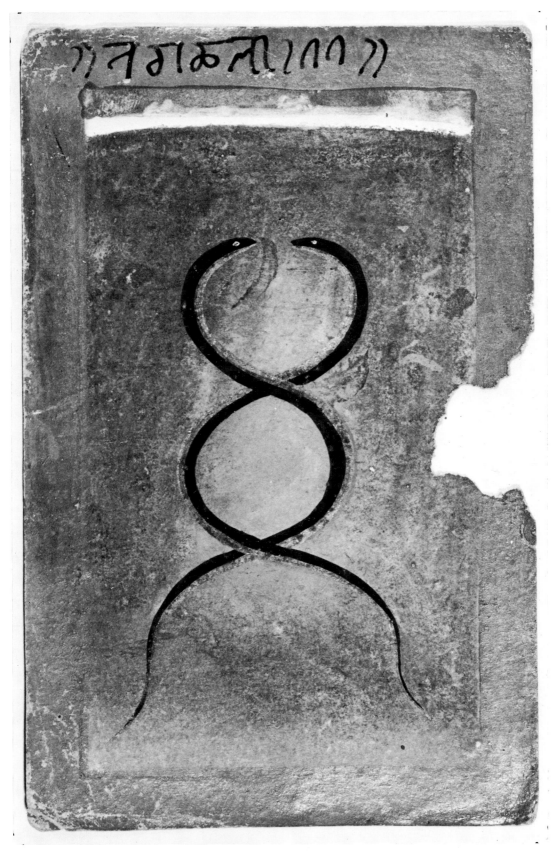

40 Snakes symbolizing cosmic energy coiled round an invisible lingam (male organ). Basohli, *c.* 1700. Gouache on paper 6 × 4 in.

41 (*overleaf*) A Buddhist male destroyer of death united with his female Wisdom. Tibet, 18th century. Bronze h. 10 in.

42 The condition of enlightenment, where the male and female principles are perfectly combined. Tibet, 16th century. Gilt bronze with jewels, h. 11 in.

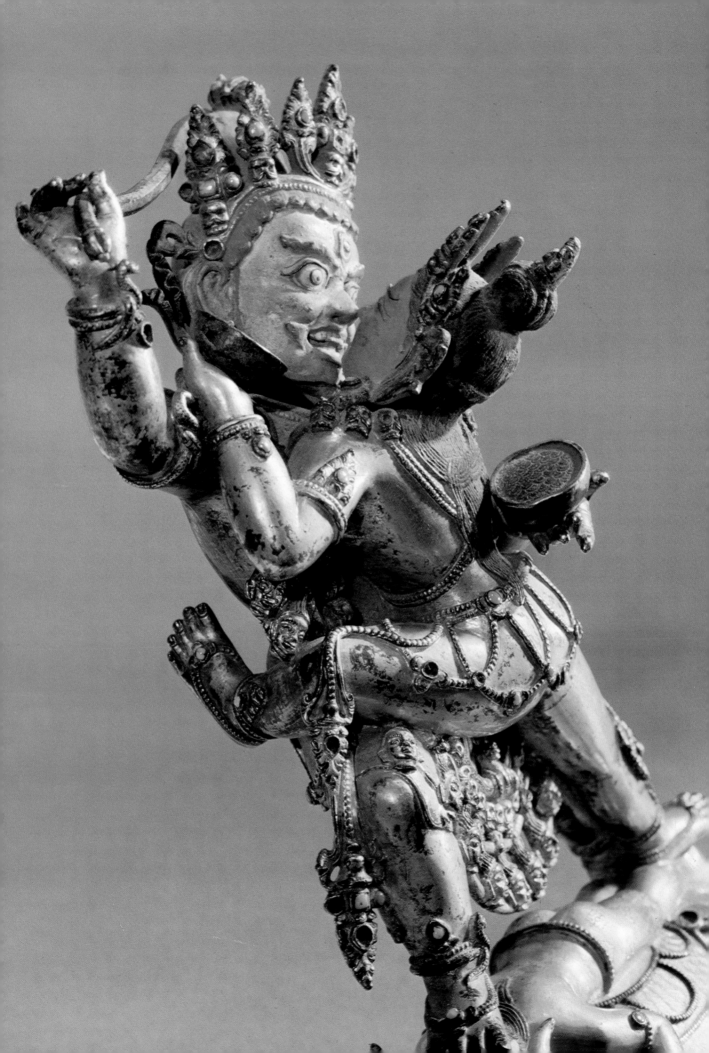

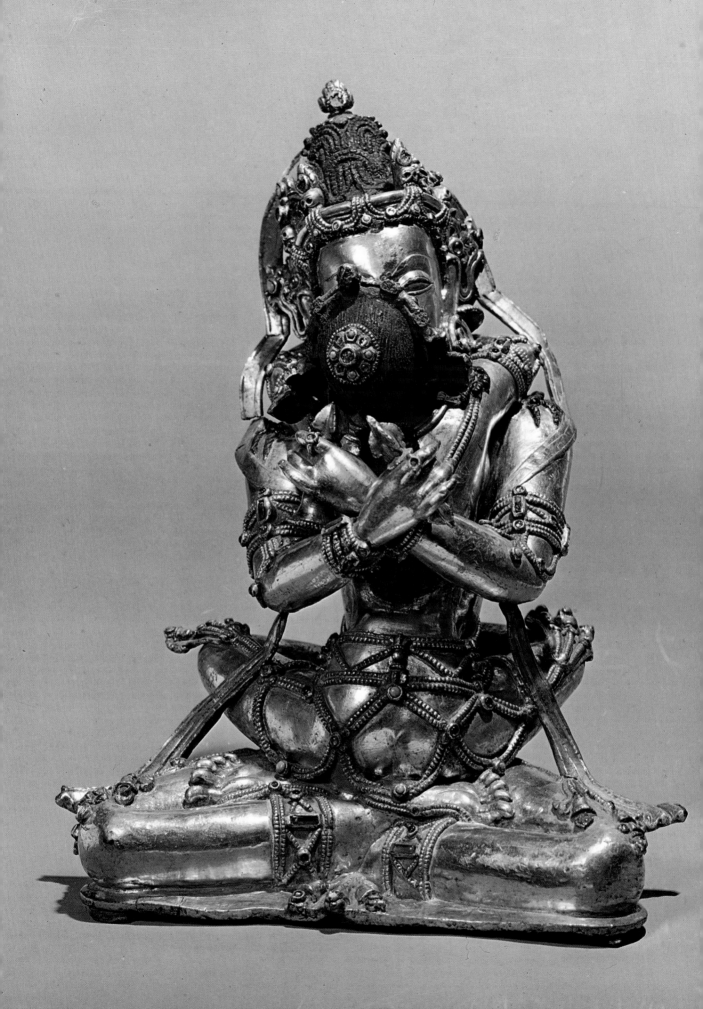

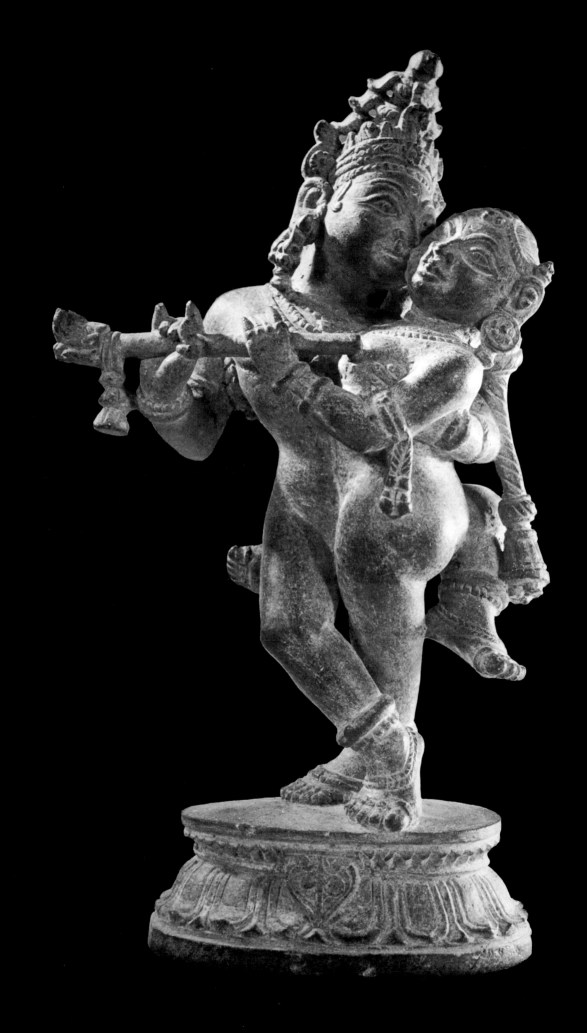

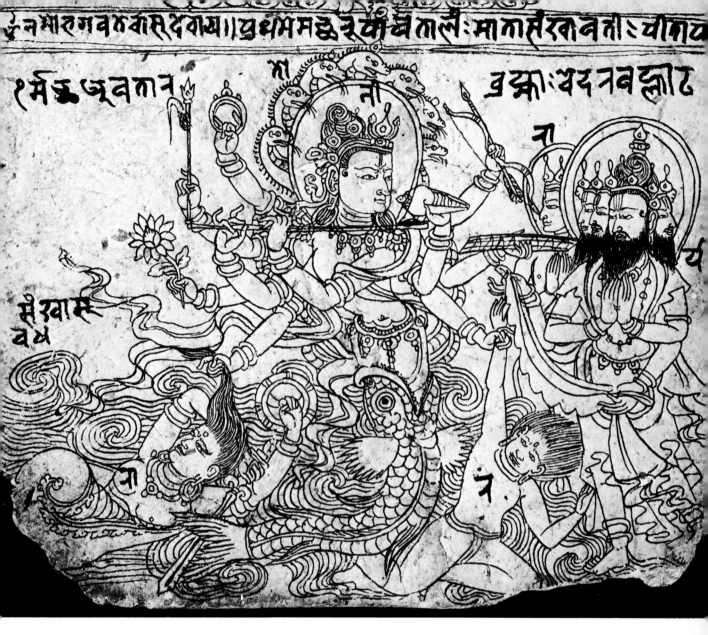

43 Krishna and Radha dancing in ecstasy. South India, 18th century. Bronze h. 4½ in.

44 Vishnu-Krishna as a Tantrik deity. Manuscript page from Nepal, 17th century. Ink on paper

45 (*overleaf*) One of the phases of love acted out by Krishna and Radha, his chief human lover, a miniature using a specially evolved colour scheme. Basohli, Jammu-Kashmir, *c.* 1680. Gouache on paper, 9 × 13 in.

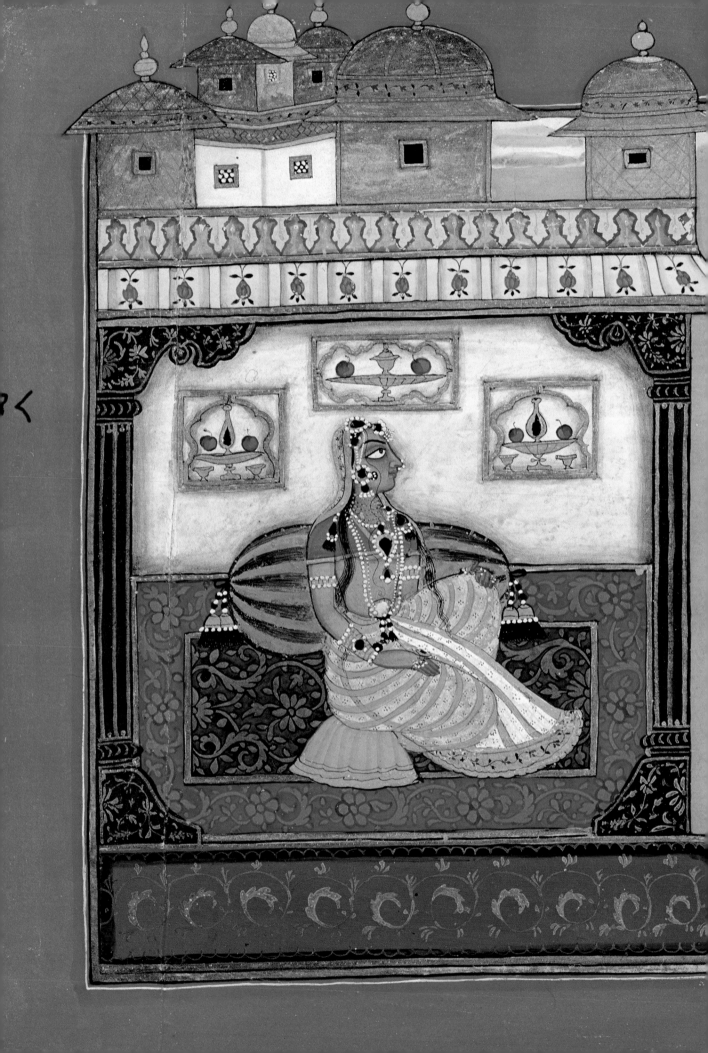

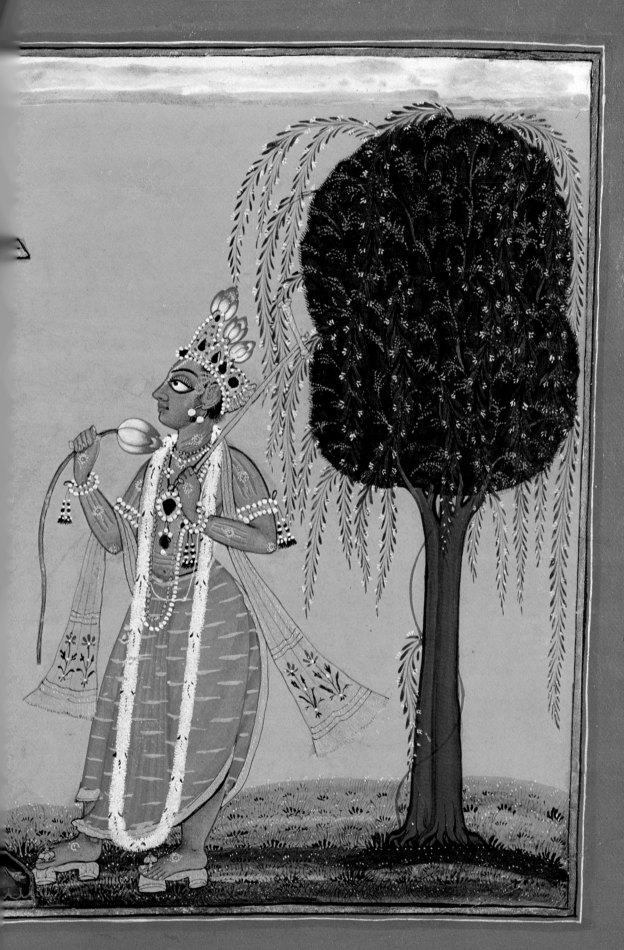

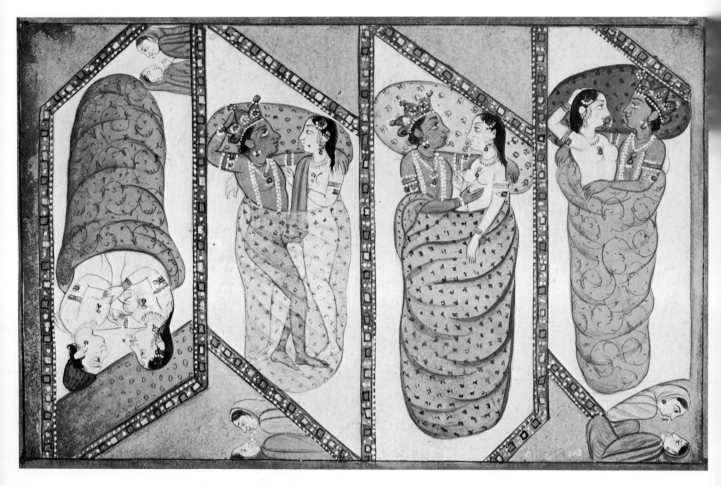

46 The loves of Krishna; on the left a human couple re-enact the divine act of love. Rajasthan, 19th century. Gouache on paper 5 × 7 in.

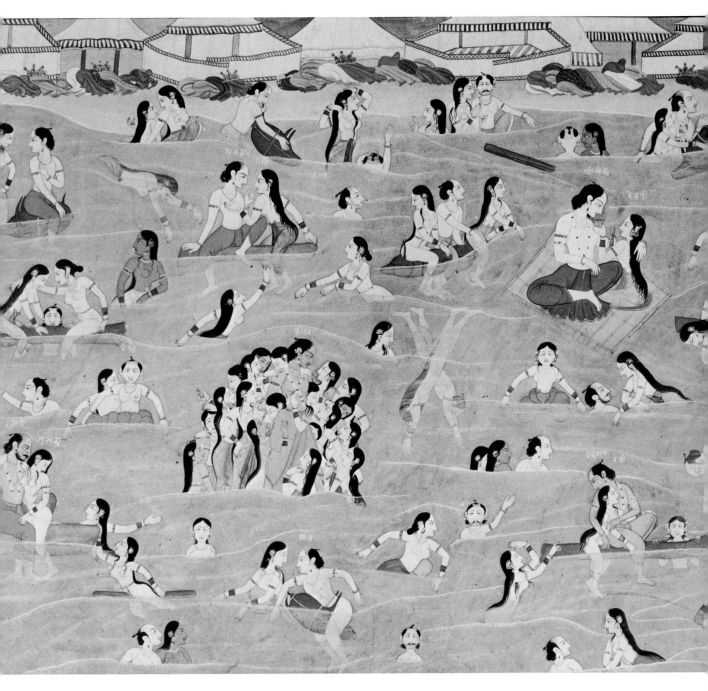

47 Krishna bathing in the river Yamuna with the Gopis (cow-girls). Kangra,
c. 1820. Gouache on paper 14 × 18 in.

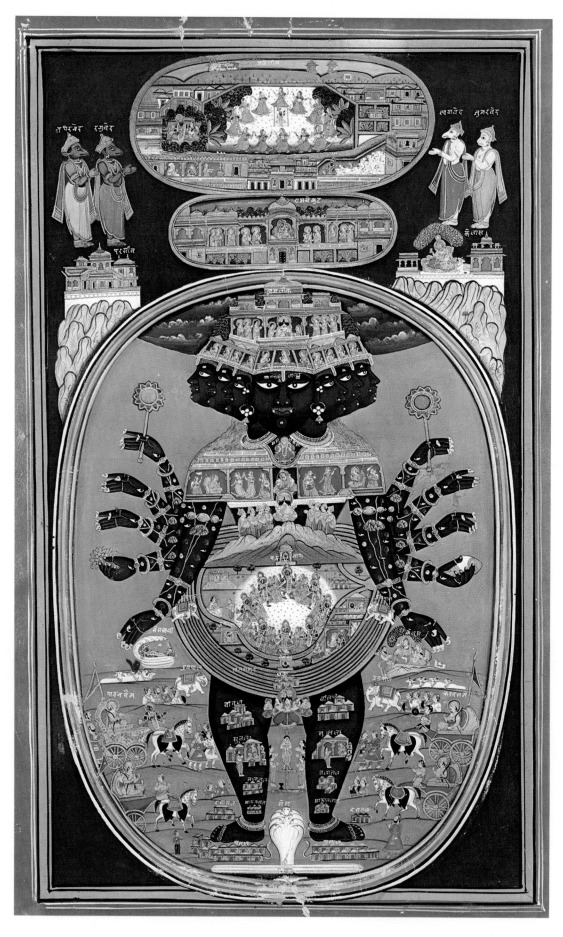

48 Krishna displaying his cosmic form. Rajasthan, 18th century. Gouache on cloth 21 × 14 in.

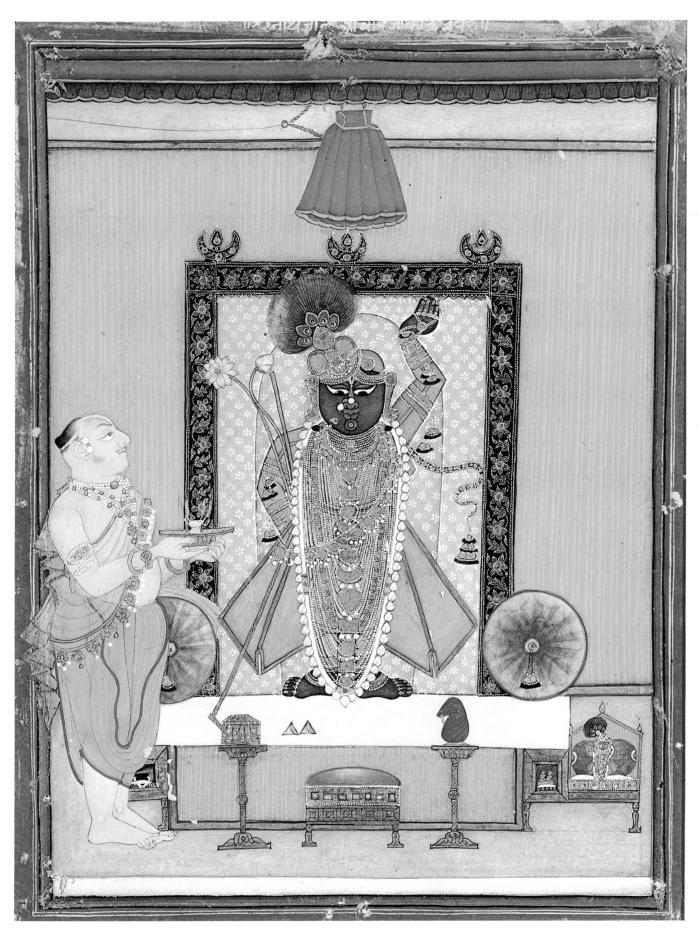

49 Krishna worshipped as the Supreme Person; a miniature from Nathdwara, where a special sacred icon is preserved. Gouache on paper 11 × 8 in.

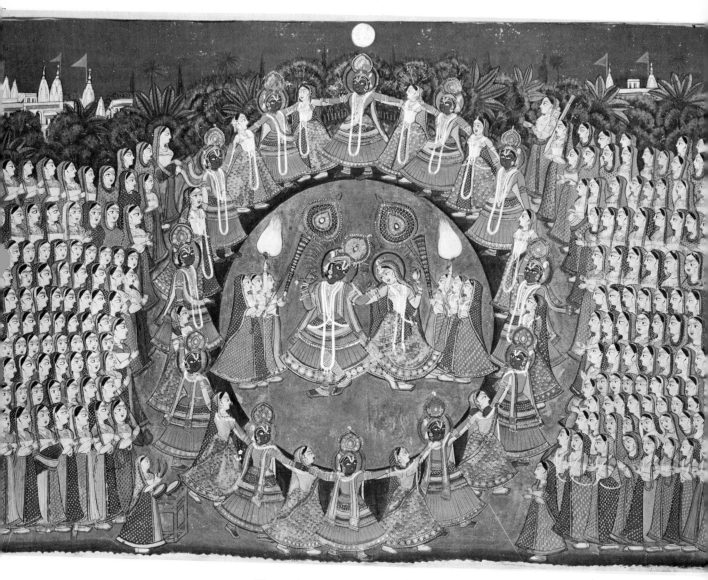

50 The springtime round-dance, during which all the Gopis were united with Krishna. Rajasthan, Jaipur, 18th century. Gouache on paper 41 × 28 in.

51 Vishnu-Krishna in cosmic form, with the lotuses or wheels (chakras) of the subtle body. Rajasthan, 19th century. Gouache on paper 9 × 6 in.

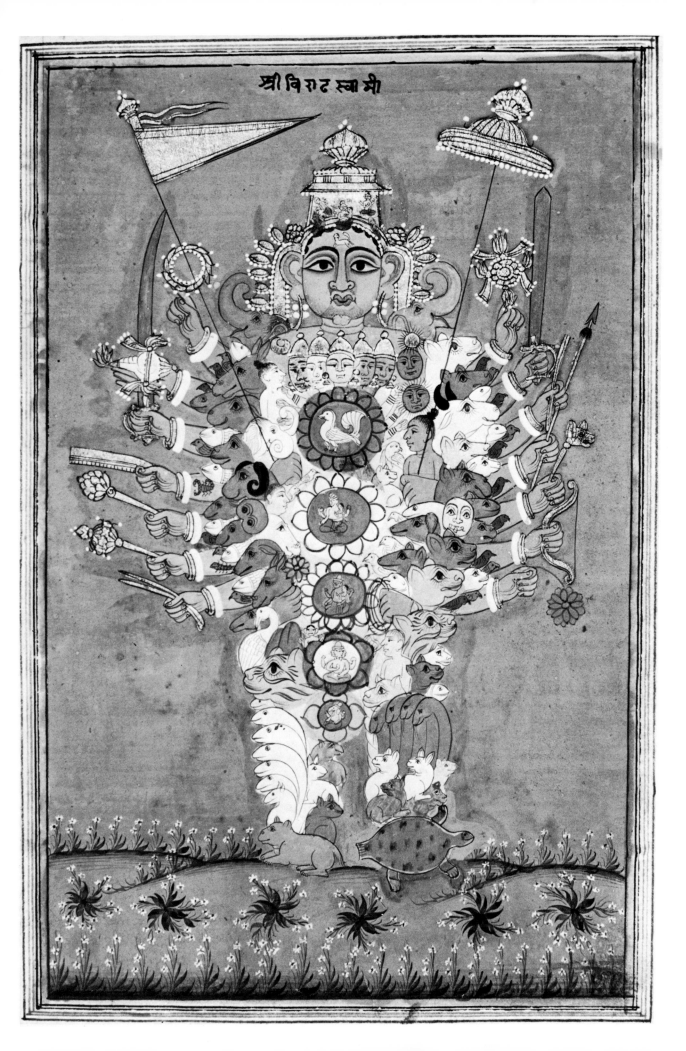

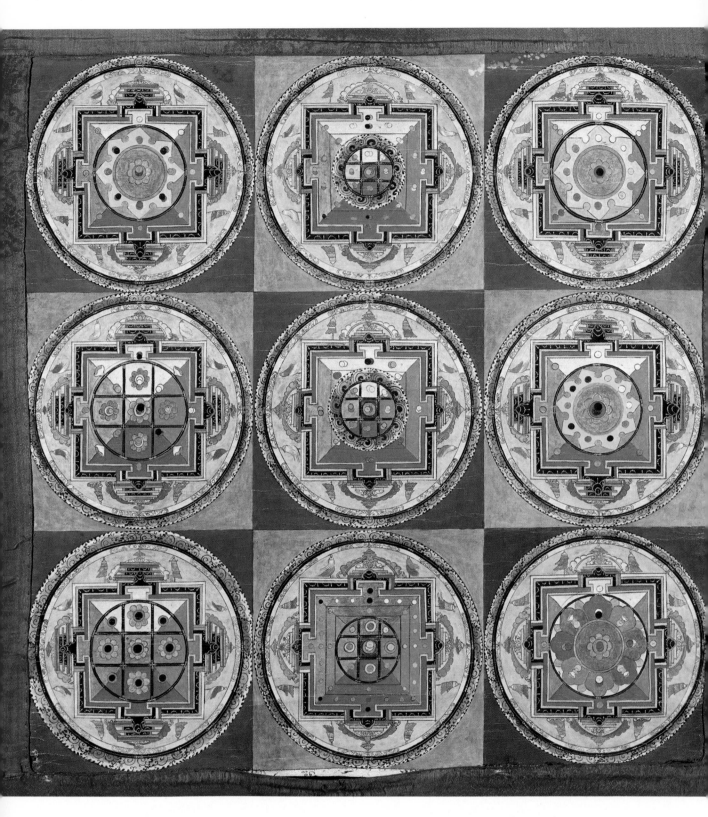

52 Tibetan hanging painting of a set of nine mandalas–yantras, used in meditation to achieve an evolved condition of consciousness. Nepal, 19th century. Gouache on cloth 22 × 22 in.

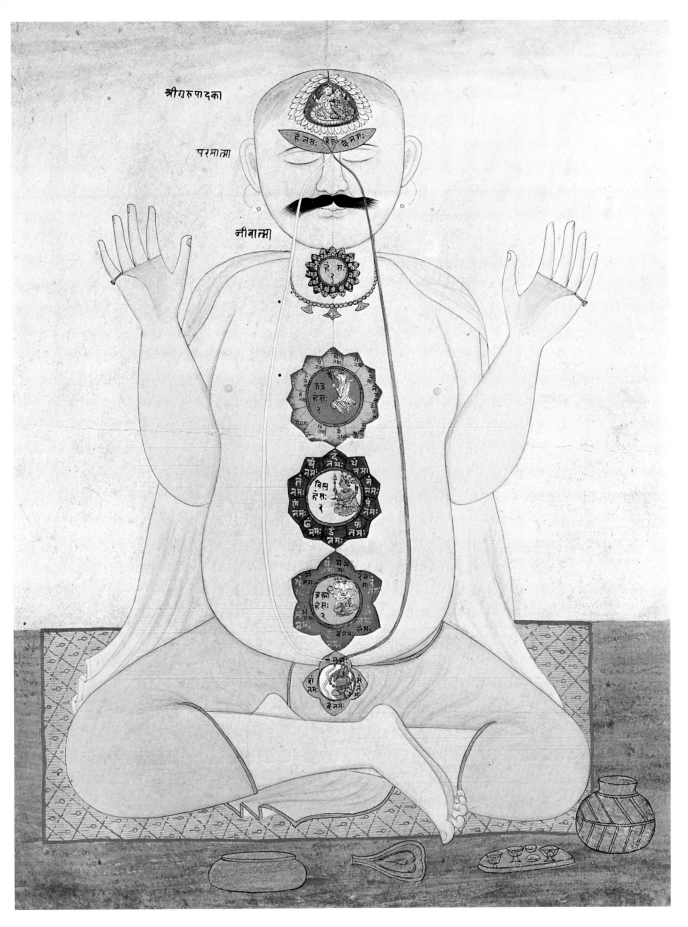

श्रीगुरुपादुका

परमात्मा

जीवात्मा

53 Diagram of the system of channels and chakras in the subtle body. Kangra, Himachal Pradesh, *c*. 1820. Gouache on paper 12 × 9 in.

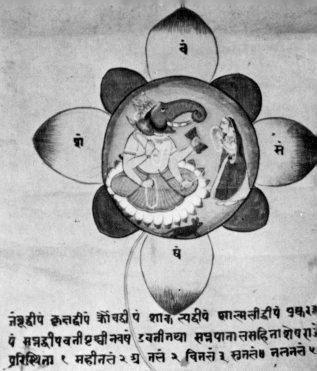

नवंमेत्राह्लादचक्षुरवस्थानेरक्तवर्णंभ्रं‌ मिरवत्नगुप्तसूक्ष्मशक्ति हंसश्चरिष्यि
नत्याह्वाहनविज्ञानशरीरं विज्ञानवस्था श्रुतमभारत्क्रमासदेवप्रसादेलिंगि
ग्रुंथमात्रा ग्राकाशनलते जीवोहंसःवे नत्यनिगलेवाहिरला हिमाक्रांतश्रे
मति हंते वह्निमोत्रा प्राणिनी ध्रुव जातुफलसहस्रं १०००० ग्रतिकास्ट
पलानि० ग्रशूजामानसिीसांहं भावे नगेचारि समर्पयामि इनिष्ठ जयेन्
ग्राकाश्चक्षुर्येर्येलुर्घरतं रक्त उ पुक्त योगाग्रम्भहापुलध्यावसंमधानासने १

श्रुष्ठमेवत्वक्रनिष्ठनिर्लेचरिर स् नेवविचिलवैयोगिश्चियैयफकाश्चुये
१ डोंकारेब्रह्म्याशक्तिशिरोद्ध कृषिःविरलेत्रिलत्रिमा० ग्रा
व्राझकारउकारमकारनल रजलमसि ब्रह्मविलरू०
प्रथिवीजलनेनोसियाका० दाना:समानश्चुरुश्यः०रसंग प्राणाच्यलो सेरूसाः देवश्चरिधर्णन्
मनासिं बुद्धिचित्तहंकारं । चकर्चैर्चैसूर्यः इशपिसश्च
स्थानाग्रुःइदसर्वेचक्रत्रिकंपयें प्रतिष्ठने चास्वामभागइद्धाश्राकारे
तेलंपिंगलास्मतासूत्रं नेत्रोमंडनाडीपुष्मामध्मा
स्मनाः १ यस्चाप्रोक्षे मिरंविश्चेपंचचटनेश्वरच
योगनिस्चप्रयत्वेनंने यासादेहवर्त्तिनी २ नाना
ज्ञानतियेसूटारथाने भास्वाहका नस्मात्रिनेचक्रे
येचिन्तनमेः ॥ १ ॥

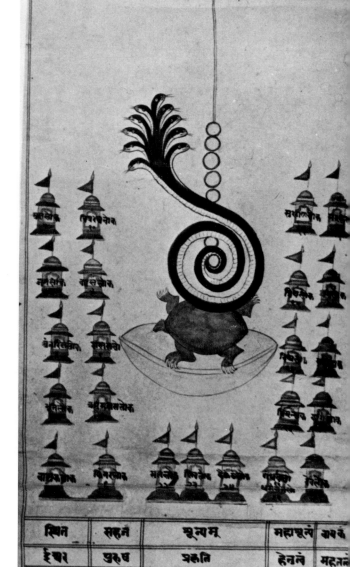

सम्मेविशुद्धचक्रकंठस्थानेधूमं वरलंजीवादेवनाच्यत्रियाशक्ति:विराट्क
श्रिवायुवाह नेज्ञानकलाजाते धरोचेपो महाकारणदेहेत्रथेवेदंसूर्य
यश्चामप्रमाराक् जगमेरन्निकं समित्ना भूमिका सानोकाग्मात्माभात्
नोऽशर्तुरेचोडे शामाग्राह्चेनमश्प्रथमावहि
मविर्१२विप्ना १ श्रविया २ इकार ३क
या ६ ज्ञा नशक्ति: ९ श्रीन
ला ६ महा विश ७ महाभा
या ९ ग्रुद्धि: नाम
सि १० म्रजा ११ मेज्ञा प
र्नी १२ कुमारी १३ गो
ग्रा १४ गोचरी १५ गो
सिंह योगश्ची १७
ग्रलु ॥ ली १८ एनक
२ पला चंद्रस्यज्ञप्रपाल
नसी सोतृंभाव १००००० ग्रतिकास्
ग्रुह्कार्चवच नि १९ ग्रजामा
ग्रुचवलिगुर्णपुक्क नश्जयेकेधारिगानि
न्मन्चाक्रचक्रिलनान् येकरस्थाने प्रतिष्ठने
ग्रुवेग्रुवलीजेगुणेवेद्रि लाळक्ष्म्याभिज्ञिने ९ विधानी
माया रुद्विस्थानामसीयुना २ म्रजांत्रभ्याग्रणीजोका
ग्रन्यात्तयारायणीयोक्ता मारीयादिकादपूर

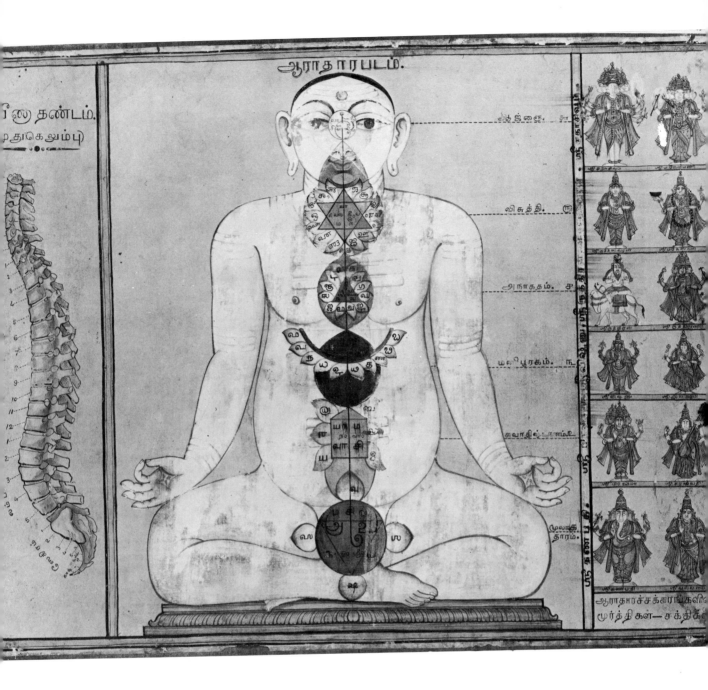

54 Scroll painting of the meditative chakras (details). Basohli, 17th century.
Ink and gouache on paper 137 × 9 in.
55 The chakras in the subtle body related to the spine and to the divinities.
Tanjore, 19th century. Ink and colour on paper 20 × 26 in.

56 (overleaf) The subtle body, with the secret celestial upper chakras and
channels (detail). Rajasthan, c. 1700. Gouache on cloth, complete diagram
121 × 19 in.
57 The subtle body with its chakras (detail). Nepal, 17th century. Gouache
on paper, complete diagram 140 × 11 in.

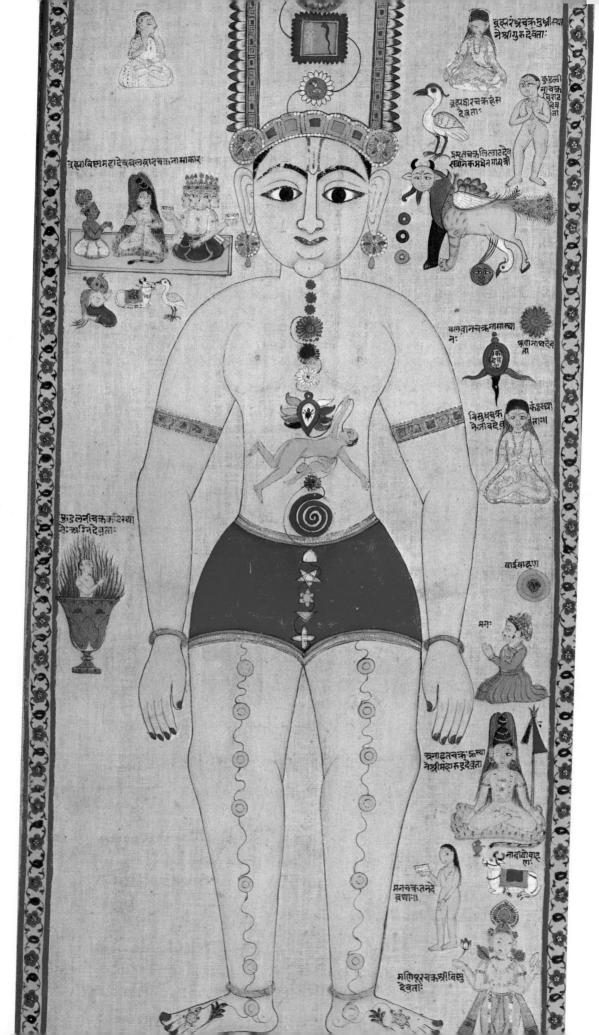

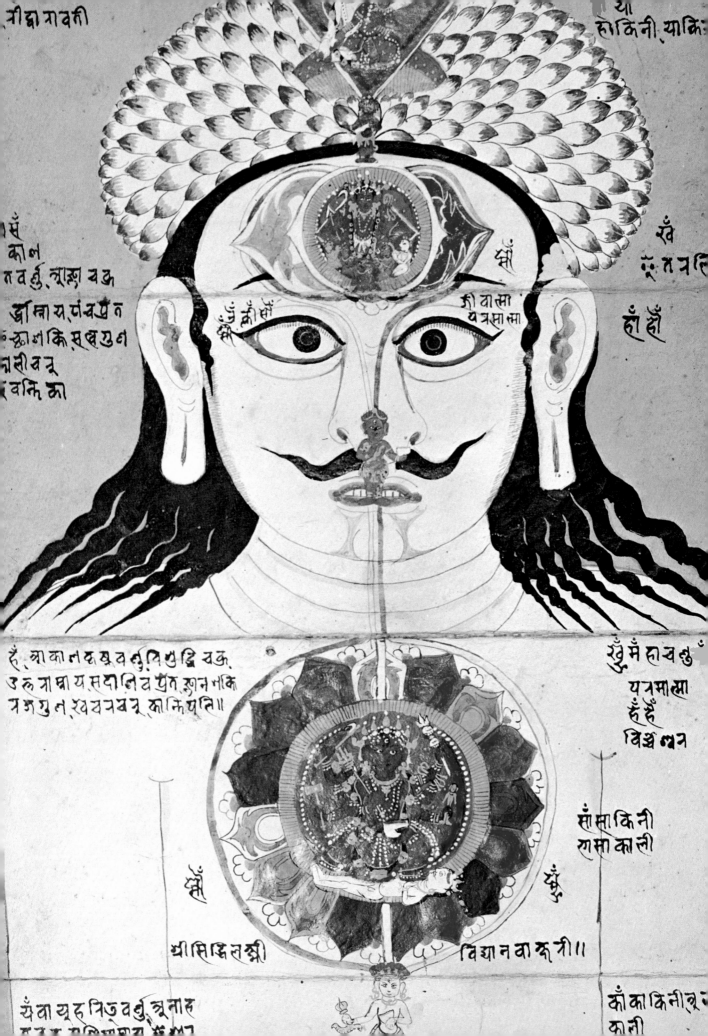

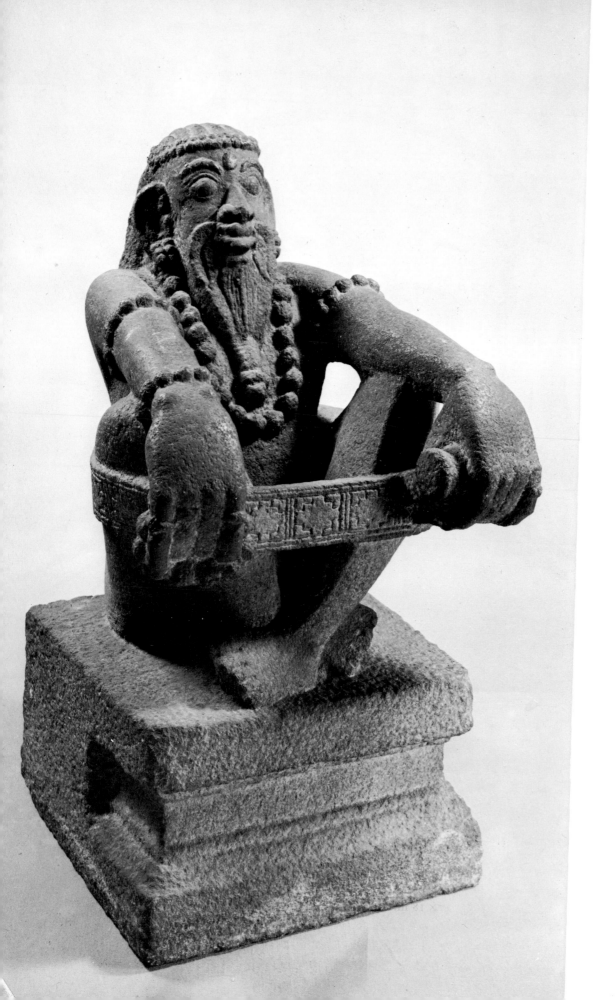

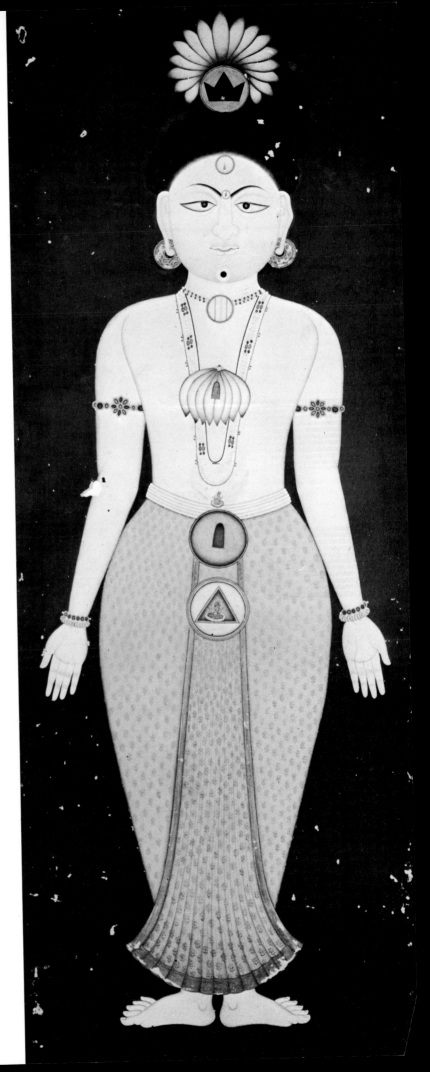

58 Sage seated in his meditation band. South India, 17th century. Stone h. 19 in.

59 The chakras of the subtle body. The transcendent flower of bliss opens from the top of the head. Rajasthan, 18th century. Gouache on paper 47 × 18 in.

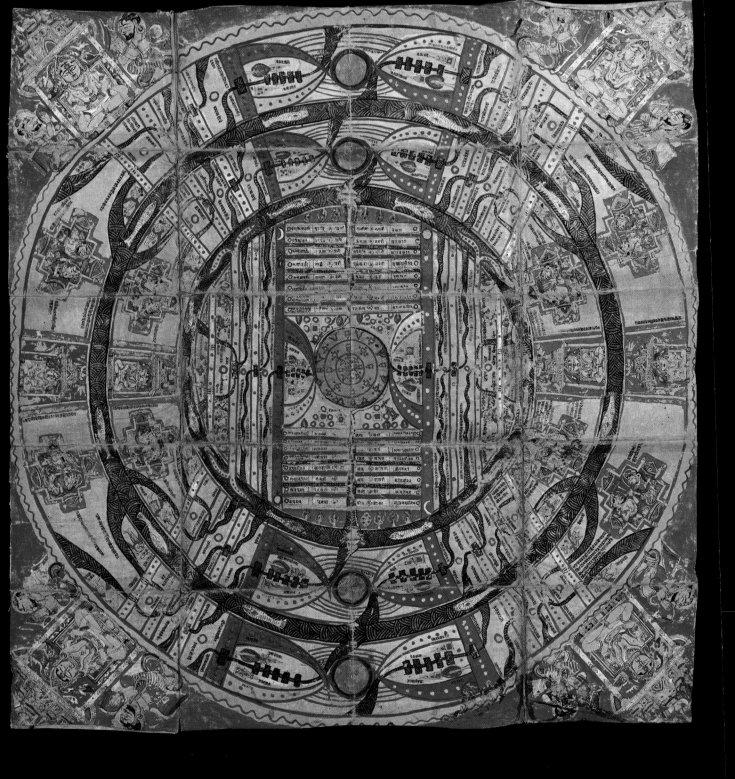

60 Jaina diagram of the primary divisions within the unified cosmos. Gujerat, 15th century. Gouache on cloth 22 × 21 in.

61 Tibetan hanging painting symbolizing a state of exalted consciousness, surrounded by subsidiary states. *c.* 1800. Gouache on cloth. One of a set of seven, each 28 × 19 in.

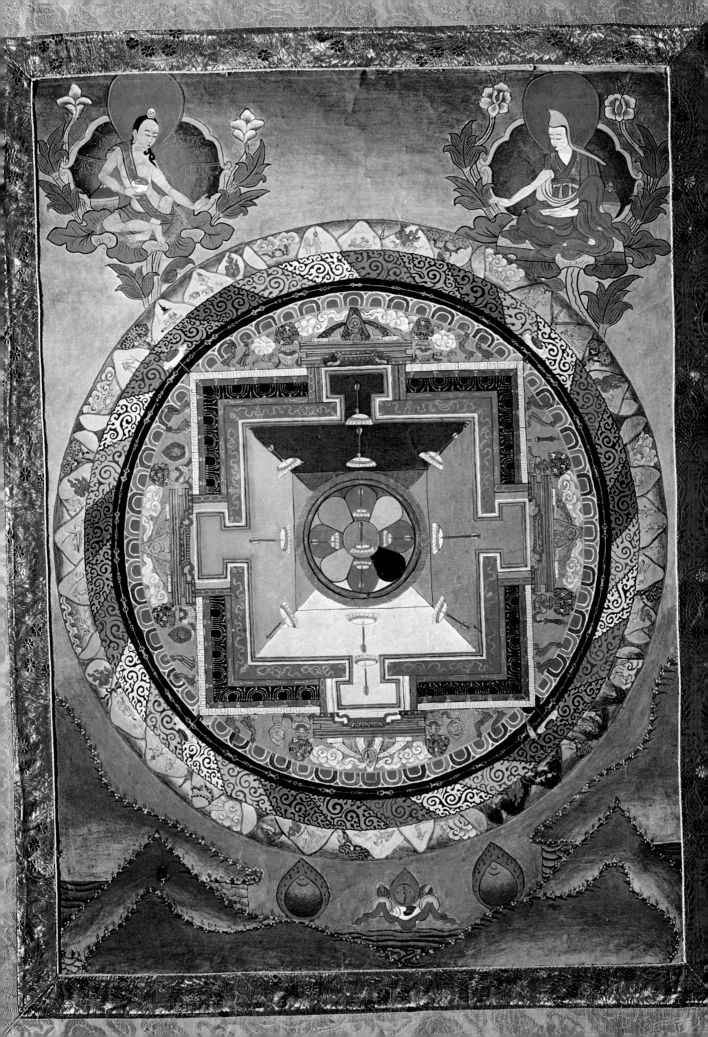

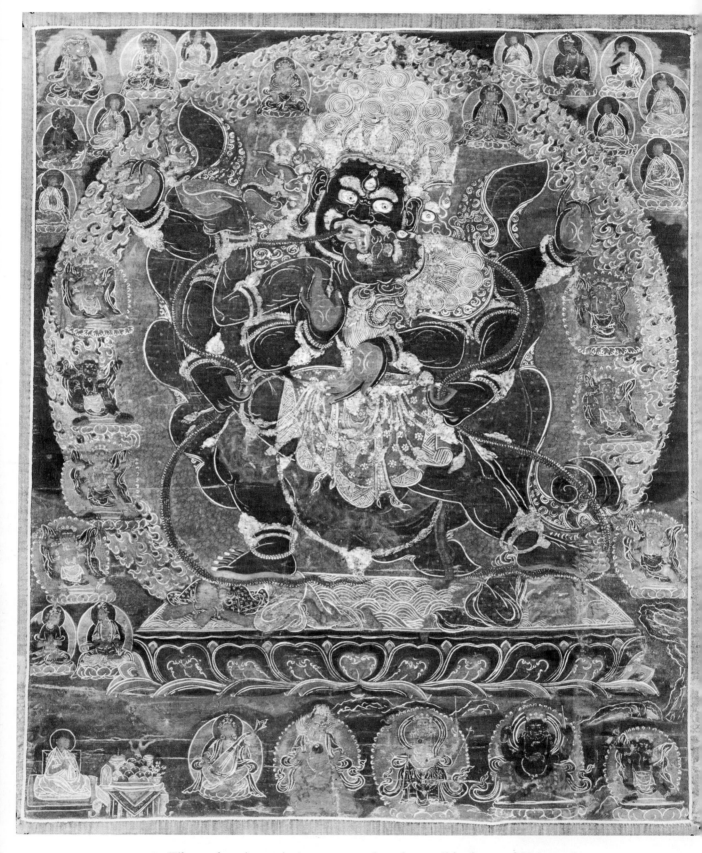

62 Tibetan hanging painting representing the terrible form of Vajrapani, protector and chief embodiment of the power of Buddhism. 17th century. Gouache on cotton 21 × 17 in.

63 The horrific deity Samvara with his female Wisdom. Nepal, 17th century. Gouache on cloth 24 × 19 in.

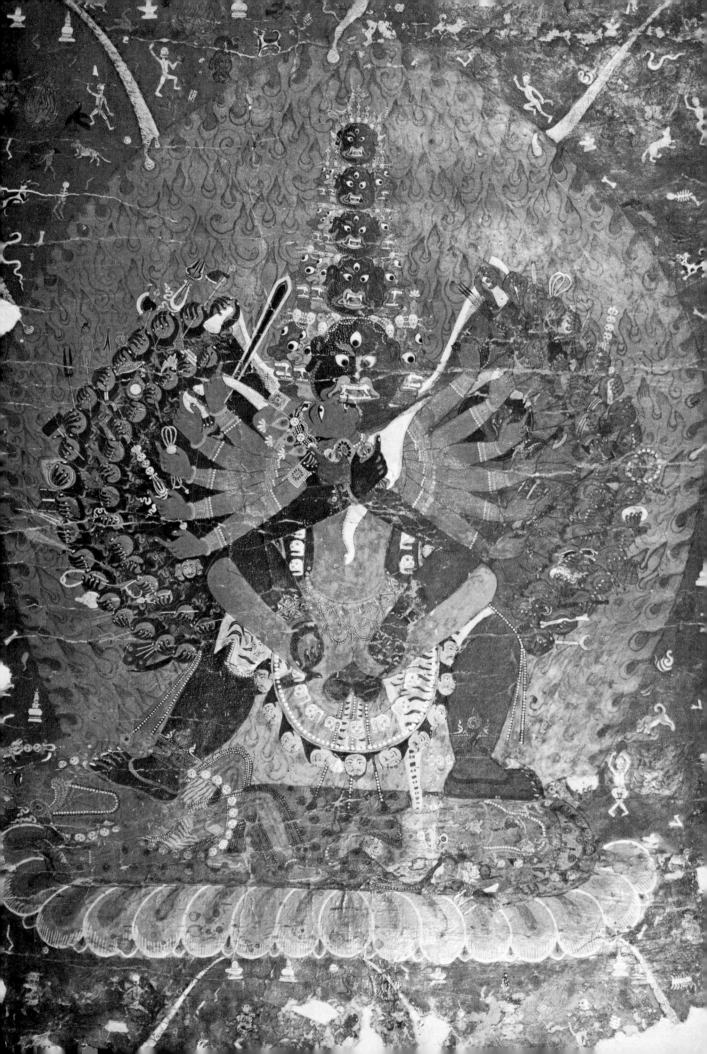

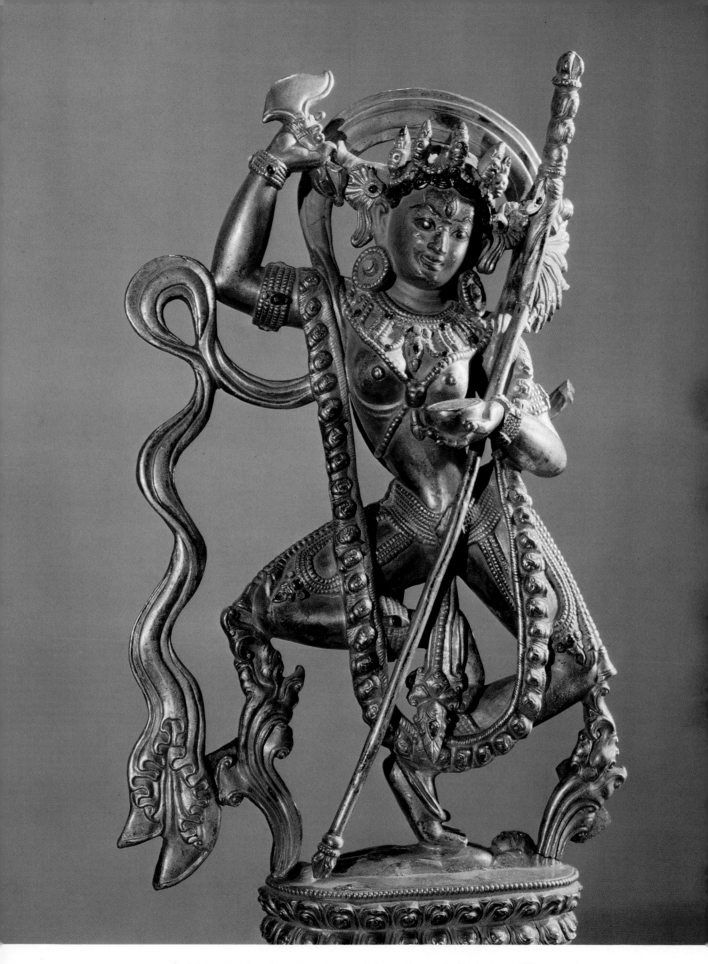

64 Dakini, the female who gives wisdom through initiation. Tibet, 17th century. Bronze h. 13 in.

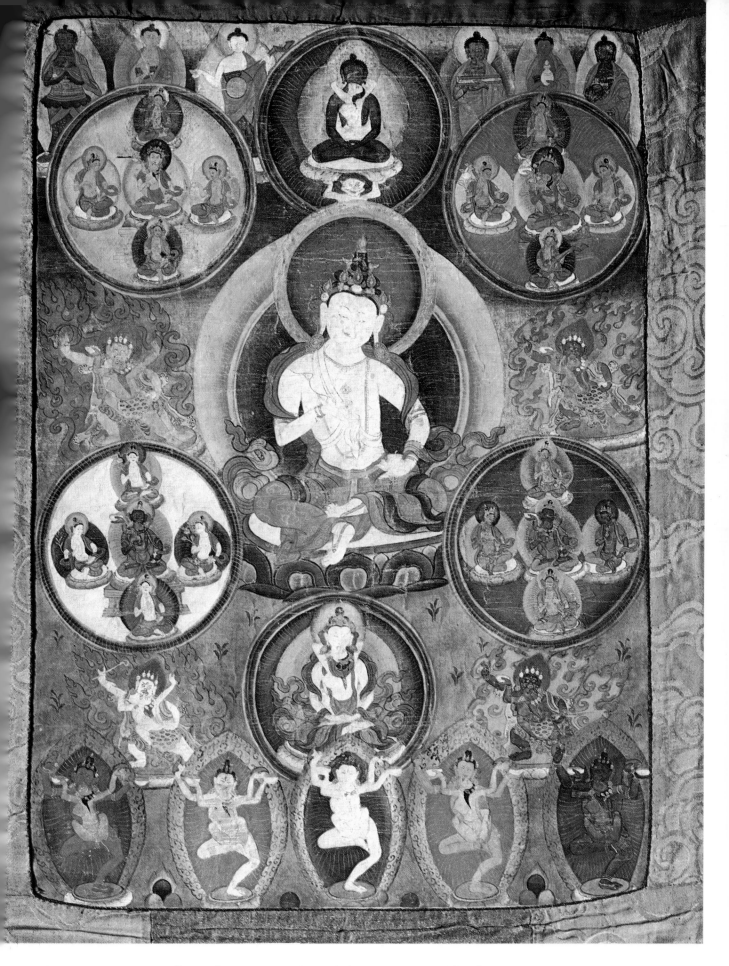

65 Tibetan hanging painting of the supreme Buddha-form Vajrasattva, personifying the central state of enlightened consciousness and surrounded by subsidiary states; he holds a vajra in his left hand. 18th century. Gouache on cloth, 26 × 18 in.

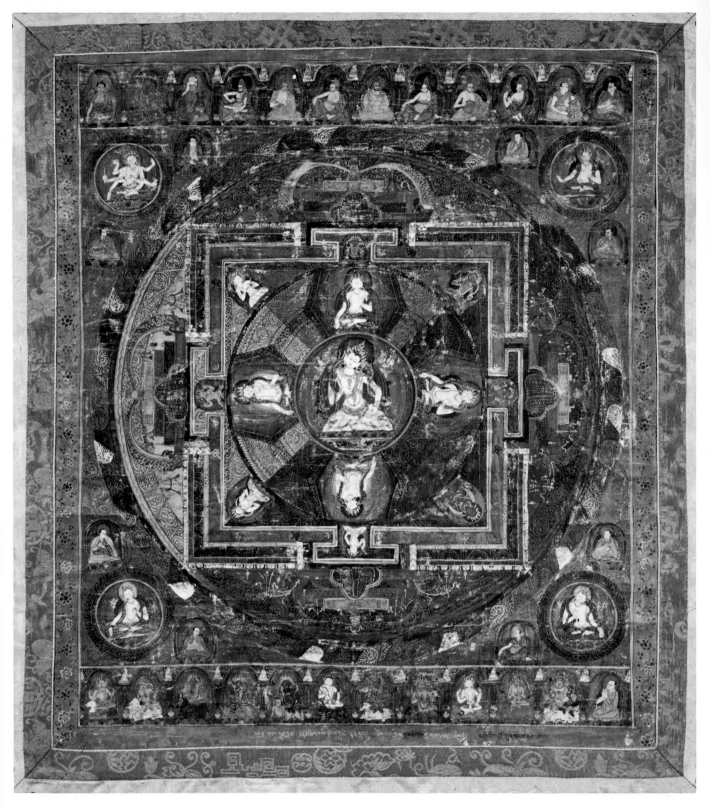

66 The mandala of the supreme Buddha Vajrasattva. Tibet, 18th century.
Gouache on cloth 21 × 17 in.

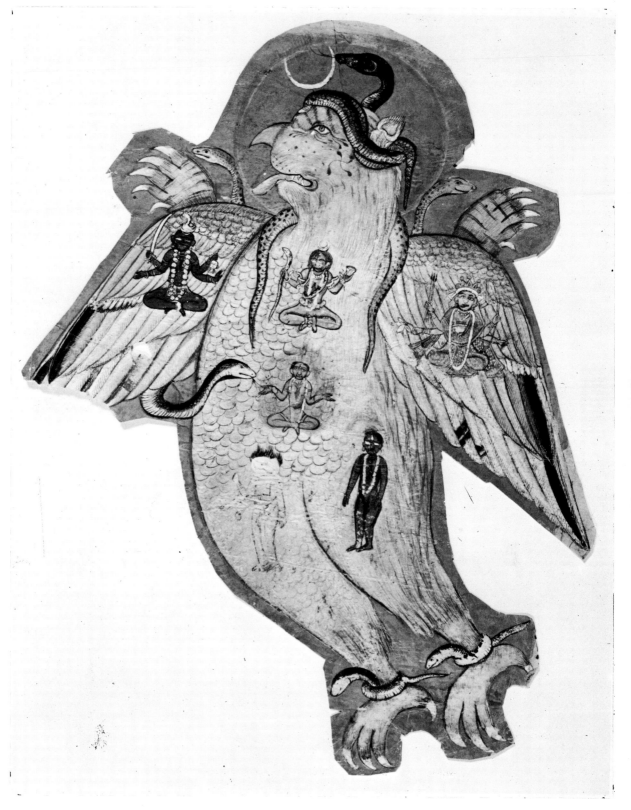

67 The mythical bird Garuda as spiritual vehicle of yogis. Kangra school, *c.* 1800. Gouache on paper 9 × 7 in.

68 (*overleaf*) Tibetan hanging painting in which the whole system of Tantrik Buddhist iconography is summarized, with the mandalas of the peaceful Buddhas, the Knowledge-Holders, and the Wrathful Buddhas. Tibet, 18th century. Gouache on cloth 29 × 22 in.

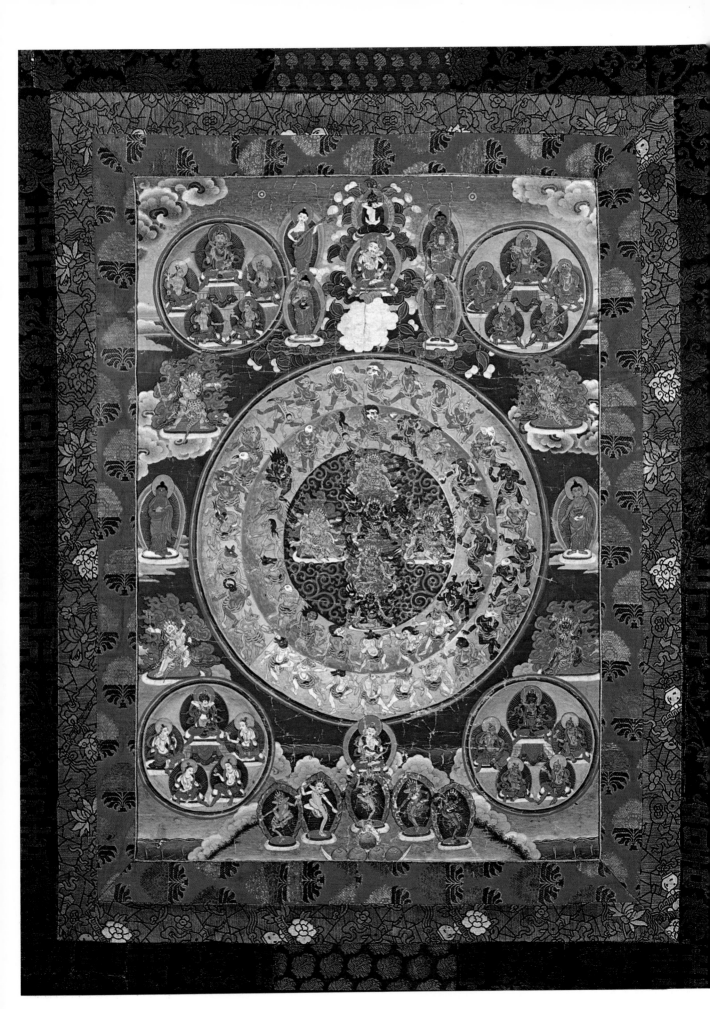

Documentary illustrations and commentaries

I Ritual and worship

TANTRIK MEDITATIVE AND RITUAL acts lead the individual by stages towards the state of clarified and radiant consciousness which is enlightenment. Tantra's special wisdom is that it does not suppress the emotions and responses, denying them any value, as more orthodox forms of Hinduism, Buddhism and Jainism do. Instead it treats them as powerful aids.

Implements and utensils are used in the ritual activities which lie at the root of all Indian religion. These consist primarily of offering such objects symbolic of the sense-realms as flowers, food, lights, bells, cloths and incense. Water and oil are used, for symbolic reasons, to anoint both the image which receives worship and the body of the worshipper, thus identifying the two.

All Tantrik worship is accompanied by mantras, syllables into which are concentrated the energies residing both in the image, the worshipper, and his world. For the vibrating essence of the whole of reality is believed to be contained within the sounds represented by the Sanskrit alphabet, which is itself thus a holy image.

1 A holy man performing ritual to emblems of the double-sexed deity. Kangra State, Himachal Pradesh, 18th century. Gouache 8 × 5 in. Victoria and Albert Museum, London.

2 Symbolic offering shaped like a flayed pig. Nepal, 18th-19th century. Beaten copper 7 × 4 in. John Dugger and David Medalla, London.

3 Set of wooden utensils for ritual with coconut oil. South India, 19th century. Wood 7–16 in. Private collection.

4 Offering dish. Tibet, 19th century. Five metals, with gold and silver appliqué of the auspicious signs. 12 × 13 in. Jean Claude Ciancimino, London.

5 Ritual water vessel, vulva-shaped. Rajasthan, 19th century. Copper 10 in. Ajit Mookerjee, New Delhi.

6 Ceremonial lamp, with spoon for replenishing oil from the reservoir. Kerala, 19th century. Brass 17 in. Ajit Mookerjee, New Delhi.

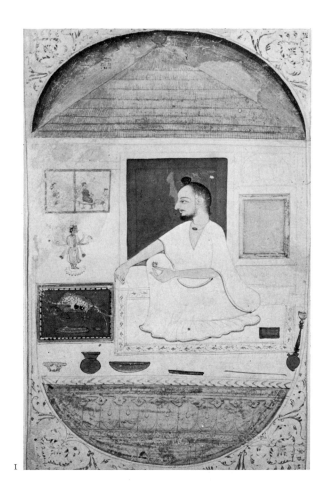

1

2

3
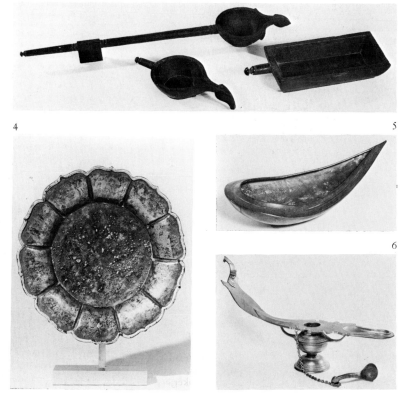

4

5

6

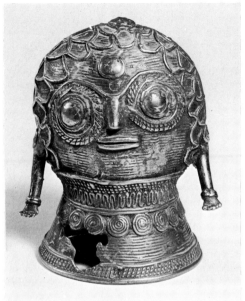

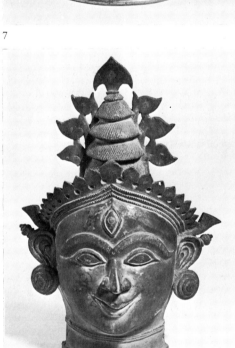

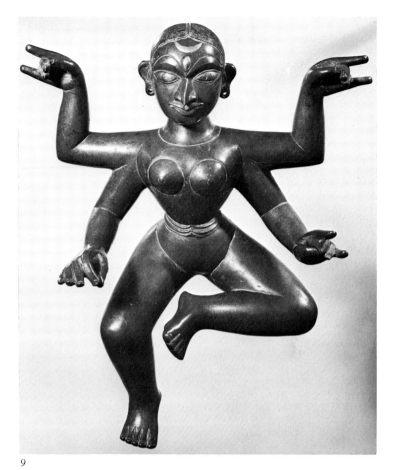

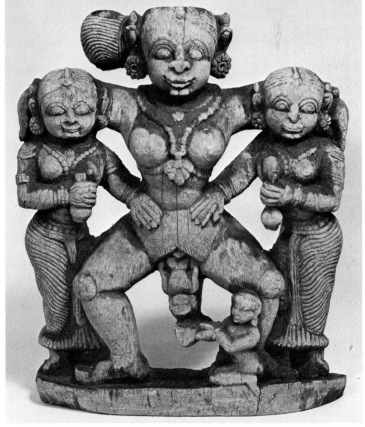

7

8

9

7 Head of the Goddess for worship; tribal work. Bengal, 18th century. Brass 5 in. Ajit Mookerjee, New Delhi.
8 Head of the Goddess Durga. Orissa, 18th century. Bronze 13 in. Ajit Mookerjee, New Delhi.
9 The Goddess Jagadamba, 'mother of the world'. Bengal, 18th century. Eight metals 15 in. Ajit Mookerjee, New Delhi.
10 Image of birth, analogue of the creative function of the Goddess. South India, 18th century. Carved wood 13 in. Ajit Mookerjee, New Delhi.

10

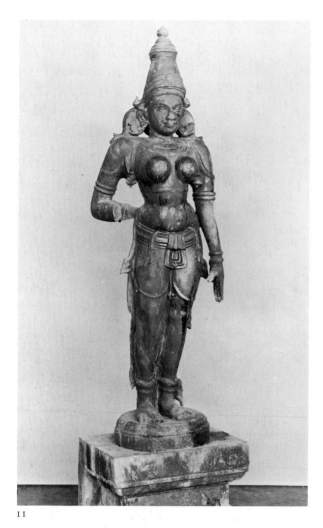

11

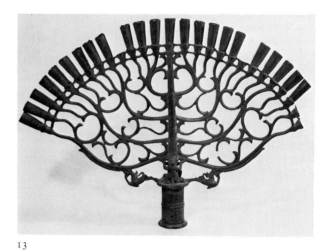

13

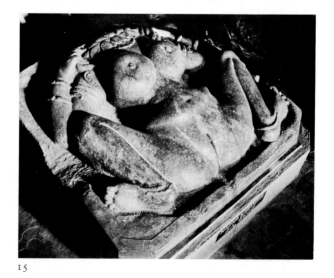

14

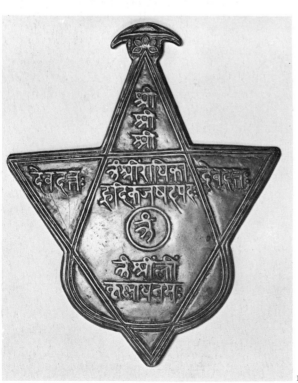

12

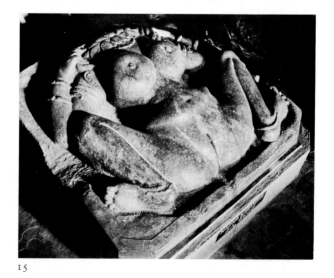

15

11 Image of the Goddess. South India, 17th century. Wood 54 in. Victoria and Albert Museum, London.

12 Yantra of Radha (beloved of Krishna) combining two yoni (vulva) forms, the pointed loop and the triangle containing the seed syllable Oṁ. Rajasthan, 18th century. Copper, cast 6 × 4 in. Ajit Mookerjee, New Delhi.

13 Incense burner shaped as a tree of life composed of serpents. Rajasthan, 18th century. Bronze 21 in. Sven Gahlin, London.

14 Necklace of sacred beads. South India, 19th century. Dried seeds 15 in. Ajit Mookerjee, New Delhi.

15 Icon of the Goddess displaying her vulva for ritual worship. Hyderabad, 11th century. Stone, from a temple. Alampur Museum, Hyderabad State.

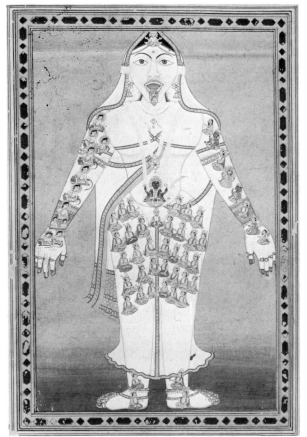

16

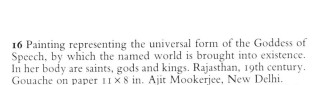

17

16 Painting representing the universal form of the Goddess of Speech, by which the named world is brought into existence. In her body are saints, gods and kings. Rajasthan, 19th century. Gouache on paper 11 × 8 in. Ajit Mookerjee, New Delhi.

17 Detail of fabric woven with repeated invocations of the functional aspects: Kali, Tara, Sodashi, Bhuvaneshvari, Bhairavi, Chinnamasta, Sundari, Baglamukhi, Dhumavati and Matanghi. Bengal, 17th century. Silk, worn by devotees 50 × 79 in. Ajit Mookerjee, New Delhi.

18 Garland of letters, yoni-shaped rosary containing an image of Cosmic Creation by Brahma, who rises from Vishnu reposing on the Serpent of non-Being. Rajasthan, 19th century. Gouache on paper 6 × 4 in. Ajit Mookerjee, New Delhi.

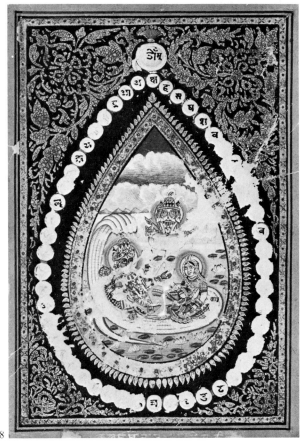

18

II Sex and reality

Tantra's view of the final goal is shaped by a vision of cosmic sexuality. The male principle of Universal Creation is the seed of Being, which is at the same time infinitesimally small and all-embracing. It is often called Shiva, and represented by an erect male organ, or lingam. The female principle, projected from the male, is the Goddess, or Shakti, who is the active partner, spreading out space, time and Universe before each individual. She is thus nearer for worship than the male principle, in many guises and under many names. Most important is the reverence paid to her as the female generative organ of the world, its yoni or vulva.

Sexual intercourse is thus taken as a paradigm or symbol of divine worship and bliss. Performed in special ways with appropriate rituals and mantras it can be the most powerful possible aid towards the goal of enlightenment. From ancient times specially endowed female initiators have been the partners in advance sexual rituals. In Tibetan Tantra these have been translated into the image of the dancing (often red) Dakini.

19 Carving representing heroic delight in the heavens; the man, who embodies the masculine principle enjoying and giving enjoyment to many women at once, according to the pattern suggested in the old Sanskrit epics. South India, 18th century. Wood 22 in. Ajit Mookerjee, New Delhi.

20 Couple in sexual intercourse, from the 'heaven bands' of a temple. Rajasthan, 13th century. Sandstone 11 in. Ajit Mookerjee, New Delhi.

21 Couple in sexual intercourse, from the 'heaven bands' of a temple, the woman exhibiting her 'creeper-like' nature, winding about the man. Madhya Pradesh, 13th century. Sandstone 13 in. Ajit Mookerjee, New Delhi.

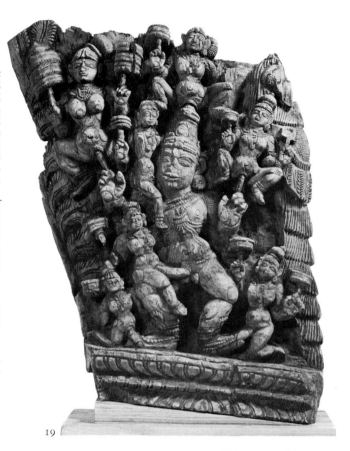

19

20

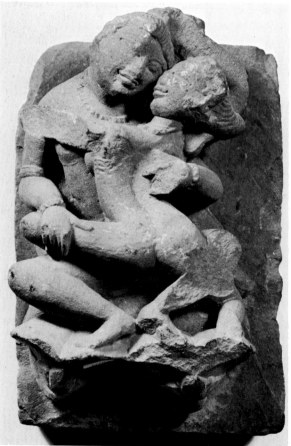

21

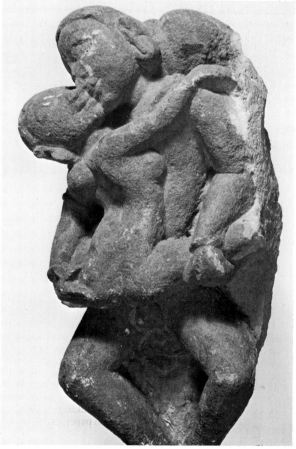

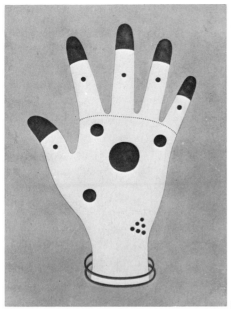

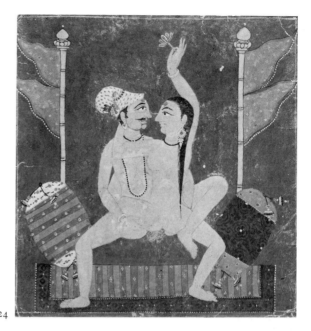

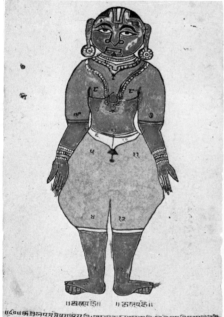

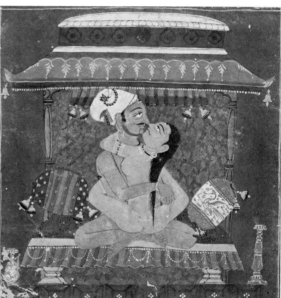

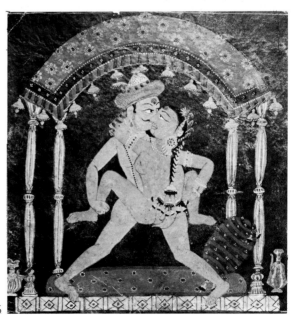

22

24

25

26

23

22 Diagram of the ritual decorations applied to a woman's hand after ritual bathing to stimulate special energies through energy-channels at those points. Rajasthan, 19th century. Gouache on paper 11 × 7 in. Ajit Mookerjee, New Delhi.
23 Painting illustrating the varying points of sensibility on a woman's body throughout the lunar month. Gujarat, 16th century. Gouache on paper 10 × 4 in. Ajit Mookerjee, New Delhi.
24–6 The sexual postures Canchala Asana, Sukhapadma Asana and Yoni Asana. Nepal c. 1700. Gouache on paper, each 7 × 7 in. Ajit Mookerjee, New Delhi.

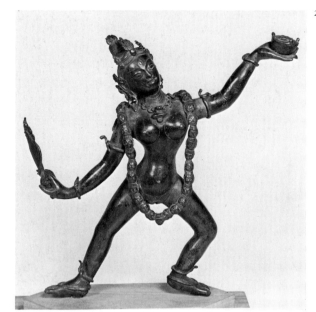

27

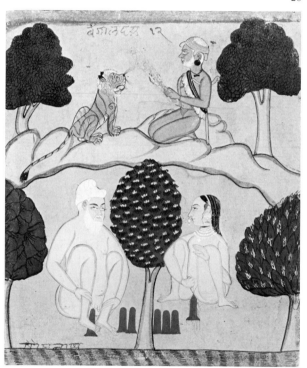

28

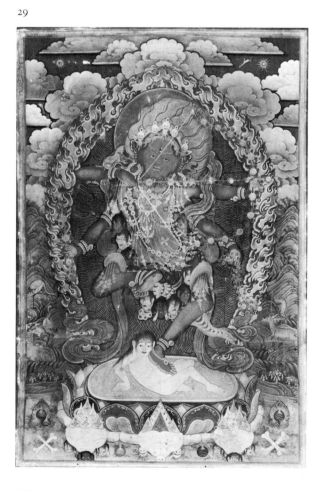

29

27 Dakini. Nepal, 18th century. Bronze 8 in. Ajit Mookerjee, New Delhi.
28 An initiation; symbolic lingams are brought into contact with the genitals of male sage and female Shakti to charge them with power. Rajasthan, 18th century. Gouache on paper, 7 × 6 in. Ajit Mookerjee, New Delhi.
29 Red Dakini. Tibet, 18th century. Gouache on cloth 10 × 8 in. Gulbenkian Museum, Durham.

III Krishna

The legend of the blue-skinned incarnate God Krishna, based on folk-hymns and spring-harvest ceremonies, deals with his passionate love affairs with cowherd girls, called Gopis. On one occasion, he revealed himself as containing the whole universe of worlds with their men, animals and all the heavens in his body.

The cult of Krishna provided the theme for an enormous quantity of post-medieval art. The minutiae of the divine love affairs inspired vast quantities of superb painting (and music), especially at the 17th–18th century Rajput courts. All this art was strongly conditioned by Indian thinking on aesthetics, a subject which was dominated by a great Tantrik philosopher called Abhinavagupta (c. AD 1000).

30 Krishna and Radha. Orissa, 18th century. Gouache on cloth 40 × 39 in. Ajit Mookerjee, New Delhi.
31 The loves of Krishna. Manuscript illumination. Orissa, c. 1600. Palm leaves each 2 × 7 in. Ajit Mookerjee, New Delhi.
32 Emblem carried by devotees of Krishna, symbolizing their Saint Chaitanya. Navadvipa, West Bengal, 18th century. Brass 16 in. Ajit Mookerjee, New Delhi.
33 Krishna as compound of animals symbolizing the other major Hindu deities. Kulu, c. 1730. Gouache on paper 6 × 9 in. Sven Gahlin, London.

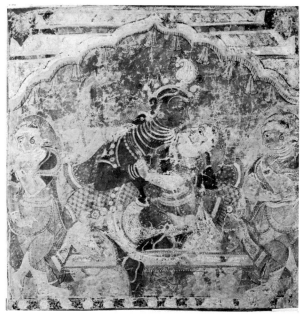

30

31

33

32

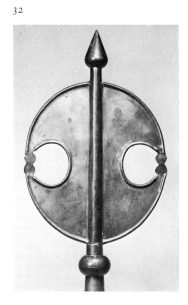

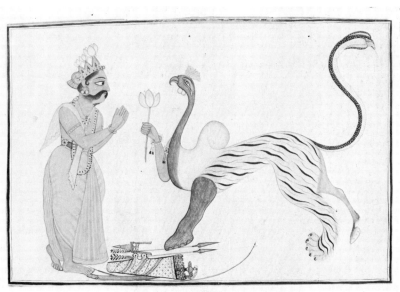

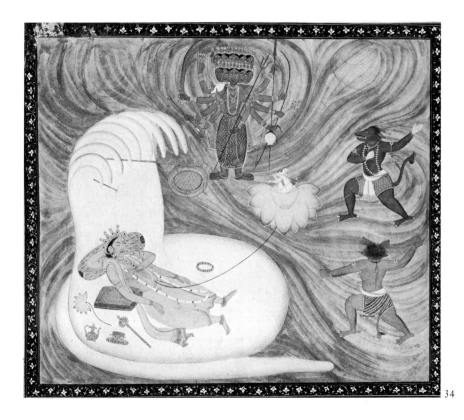

34

34 Krishna acting out the role of Vishnu in his cosmic sleep on the snake 'Eternity', with the Goddess above asserting her role as creative principle. Kangra, Himachal Pradesh, 18th century. Gouache on paper 10 × 12 in. Ajit Mookerjee, New Delhi.

35 The footprints of Vishnu, traces of his self-revelation as Cosmic Man. Rajasthan, 18th century. Gouache on paper 8 × 7 in. Ajit Mookerjee, New Delhi.

36 Vishnu-Krishna in his cosmic form, with the celestial Goloka (cow-world) above his head. Tanjore, c. 1800. Gouache on cloth 13 × 8 in. Ajit Mookerjee, New Delhi.

35

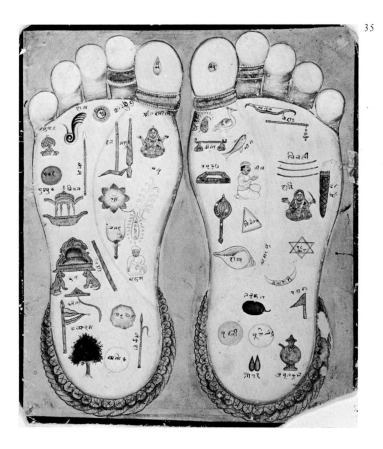

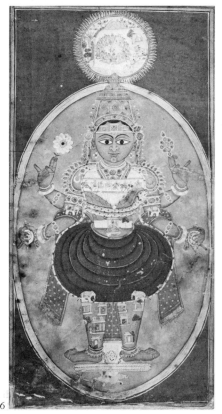

36

IV Death and fire

The loving Goddess of Creation and Bliss has another face. She brings man into Time and the world. She also removes him from it. She is thus his destroyer, the war, disease, and famine lady. No-one can be a successful Tantrika unless he has first assimilated this aspect into his image of her. Tantrik ritual therefore includes ceremonies which involve facing and absorbing, in all their hideous detail, the realities of corruption and death. The image of the Goddess in this aspect is Kali, the Black One. She is often sexually united with the passive, corpse-like male principle. Meditation with sexual ritual among the corpses at night is an essential Tantrik rite, which is totally defiling from the Indian caste point of view. During it, all a person's atavistic dreams may be personalized, confronted, and absorbed. Magic of various kinds may be based on such rites, using implements of human bone.

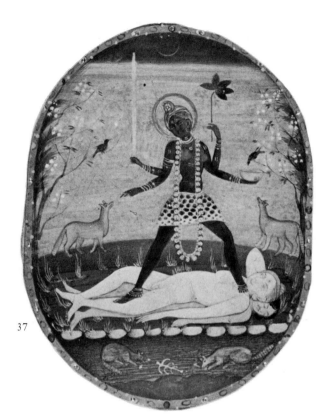

37

37 The Goddess Kali in a cemetery. Mandi, *c.* 1800. Gouache on paper 4 × 3 in. Sven Gahlin, London.
38 A terrible form of the Goddess Bhairavi. Panjab, 18th century. Gouache on paper 12 × 8 in. Ajit Mookerjee, New Delhi.

39

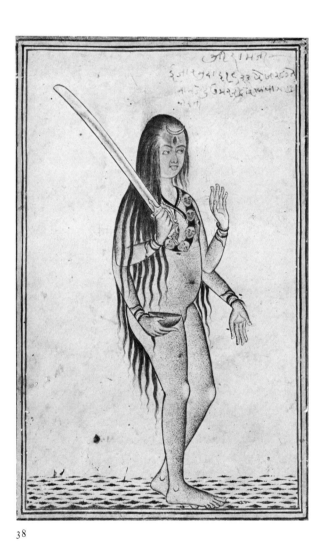

38

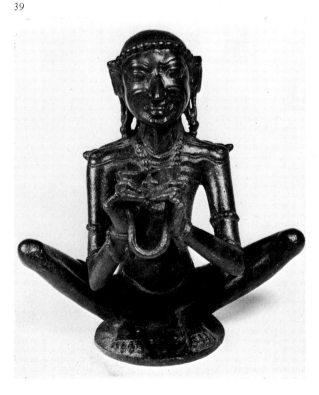

39 Image of a Terrible Devotee. South India, 13th century. Bronze 10 in. Victoria and Albert Museum, London.

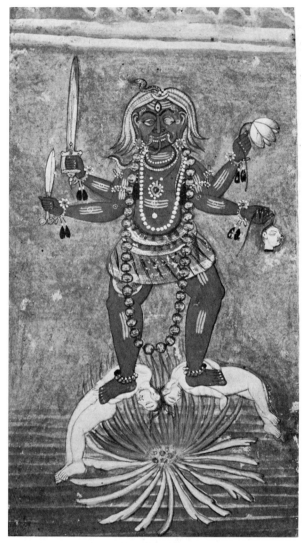

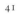

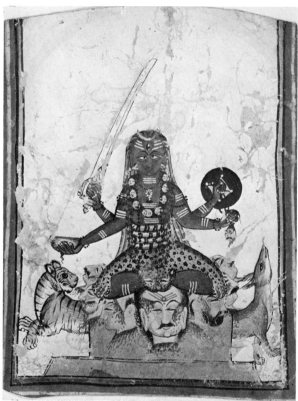

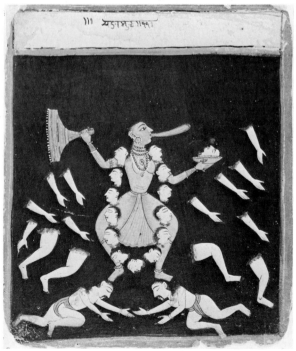

40 The terrible Goddess Kali standing on corpses. Himachal Pradesh, *c.* 1800. Gouache on paper 6 × 4 in. Ajit Mookerjee, New Delhi.
41 A terrible form of the Goddess seated upon severed heads. Mandi, Himachal Pradesh, 18th century. Gouache on paper 6 × 4 in. Ajit Mookerjee, New Delhi.
42 The Goddess Kalı as destroyer. Rajasthan, *c.* 1700. Gouache on paper 10 × 8 in. Ajit Mookerjee, New Delhi.

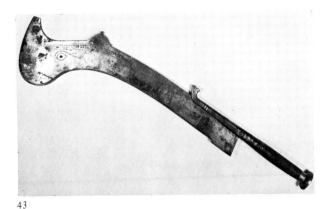

43

43 Sacrificial sword, used to slaughter animals at shrines of Kali. Bengal, 19th century. Steel l. 41 in. Victoria and Albert Museum, London.
44 The Goddess Kali seated on the corpse-Shiva. Bengal, 18th century. Brass h. 6 in. Ajit Mookerjee, New Delhi.

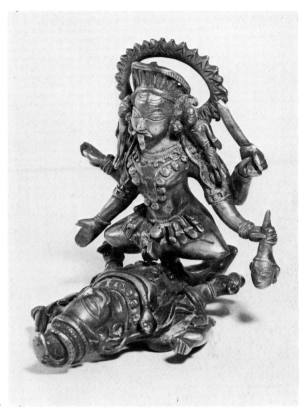

44

45 One of the ten Mahavidyas, Dhumavati ('The Smoky One'), with her crow-emblem. Basohli, Himachal Pradesh. Gouache on paper 6 × 4 in. Ajit Mookerjee, New Delhi.

46 Saint-magician making the gesture of teaching. Nalanda, Bihar, 9th–11th century. Bronze h. 5 in. John Dugger and David Medalla, London.

45

46

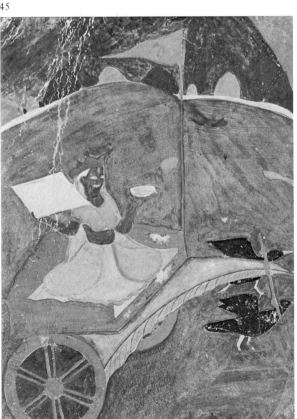

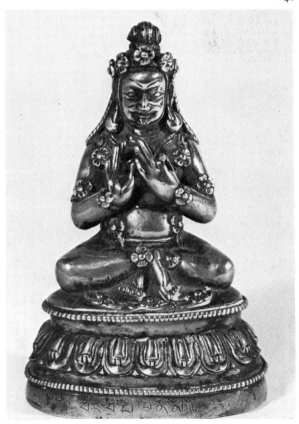

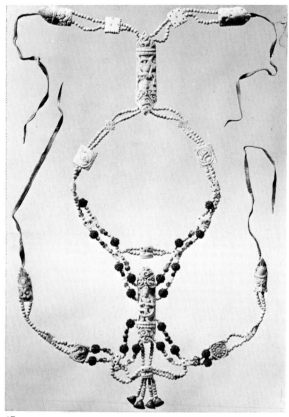

47

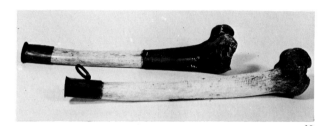

50

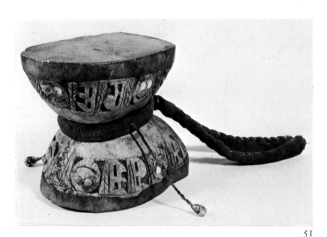

51

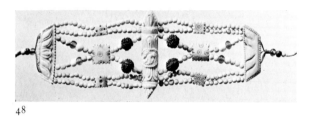

48

47–9 Magician's costume, apron and armlets, of human bone. Tibet, 19th century. 21 × 24 in. Philip Goldman, London.
50 Ritual trumpet made of human thigh bone. Tibet, 19th century. Bone 14 in. Victoria and Albert Museum, London
51 Double skull drum. Tibet, 19th century. Human bone and skin 7 in. Victoria and Albert Museum, London.
52 Gri-gug, ritual flaying-knife. Tibet, 18th century. Bronze and steel 6 in. Victoria and Albert Museum, London.

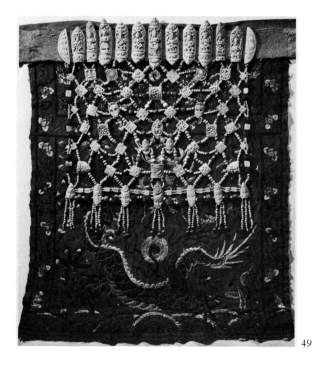

49

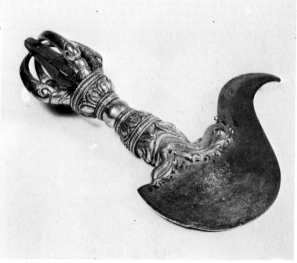

52

V Cosmic diagrams

Schematic diagrams summarize the layout of the world, in space and in time. Most are Jaina, and involve numerical calculations of a scope so stupendous that only modern astronomy can match them. The worlds are all thought of as focused around a central column, Meru. Each person appears as a tiny point in this space-time system, and astrology, very important in India, may calculate his fate, telling him how to act. Observatories are used, and horoscope-diagrams are made constantly. The constellations, planets, phases of the moon, are carefully observed, symbolized, and often personified.

53 Diagram of the cosmos, with Mount Meru at the centre, surrounded by the Celestial regions, Jaina saints in a state of release at the corners. Rajasthan, 18th century. Gouache on cloth 30 × 31 in. Ajit Mookerjee, New Delhi.
54 Diagram of the world. Western India, 17th century. Gouache on cloth 63 × 64 in. Ajit Mookerjee, New Delhi.

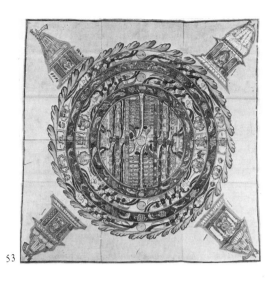

53

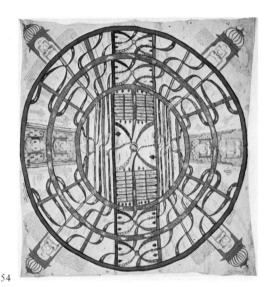

54

55 Diagram illustrating how the transcendent system of cosmic space, with its absolute directions E, S, W, N, is subtly related through layers of matter and space to the human cosmos, a page from a manuscript. Gujerat, 16th century. Ink and colour on paper 5 × 10 in. Ajit Mookerjee, New Delhi.

55

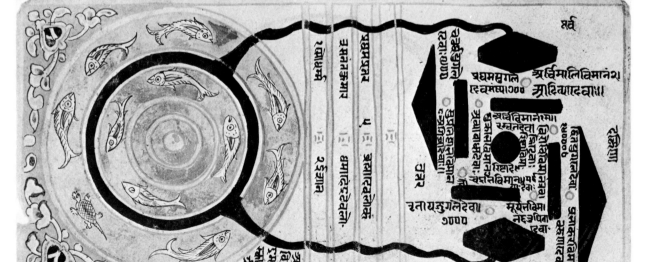

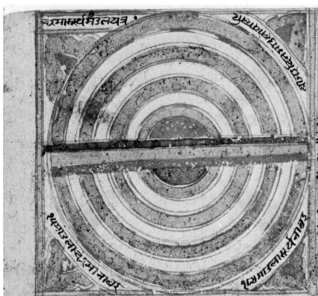

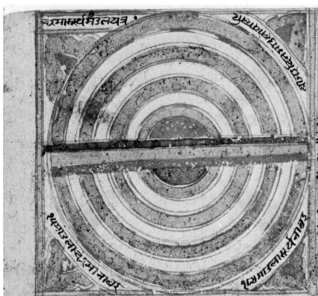

56

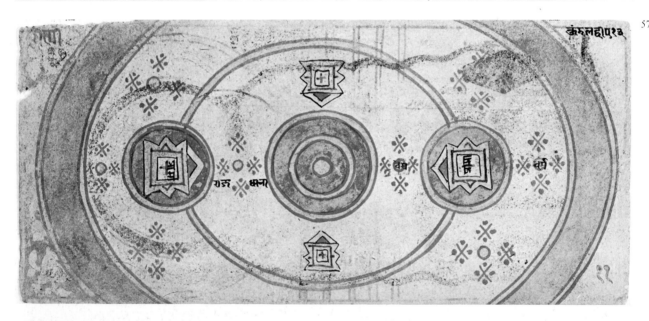

57

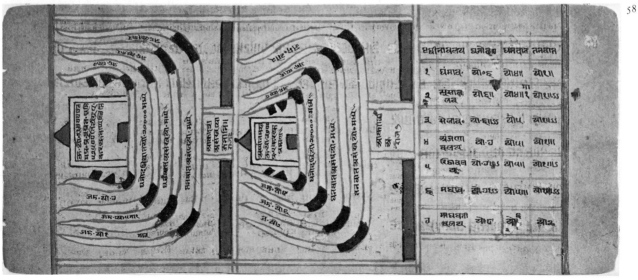

58

56 Diagram from a Jaina manuscript illustrating how the dimension of time traverses the primary separations of matter and space. Rajasthan, 18th century. Ink and colour on paper 4 × 10 in. Ajit Mookerjee, New Delhi.

57 Diagram illustrating the directional conformation of the worlds and heavens as they crystallize and separate from within the Cosmic Egg. Rajasthan, 18th century. Ink and colour on paper 5 × 10 in. Ajit Mookerjee, New Delhi.

58 Jaina diagram from a page of a text illustrating a 'side-elevation' of the world, with envelopes of progressive density towards the centre, where Mount Meru stands; the base-square is the region of moving aether. Gujerat, 16th century. Ink on paper 4 × 10 in. Ajit Mookerjee, New Delhi.

59 The 'Tree of Ages', an illustration from a book. Rajasthan, 18th century. Gouache on paper 9 × 6 in. Ajit Mookerjee, New Delhi.

60 Schematic Jaina diagram of the successive levels of the radiant world-tree, at which the levels of the Universe are reflected. Rajasthan, 18th century. Ink and colour on paper 4 × 6 in. Ajit Mookerjee, New Delhi.

59

60

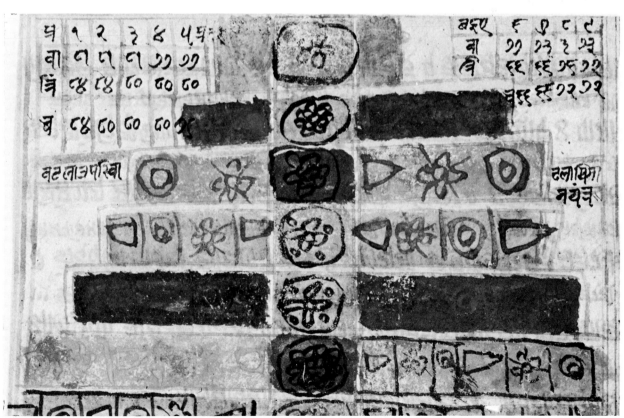

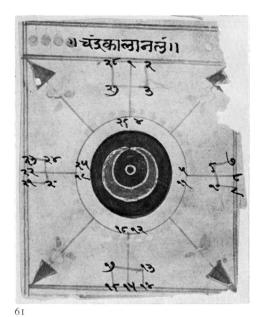

61

62

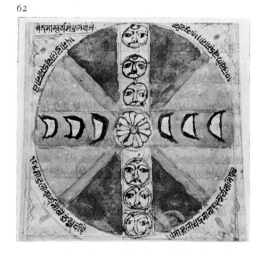

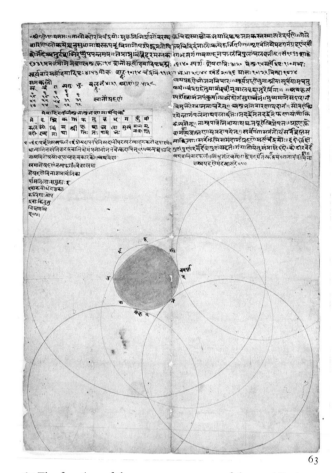

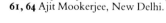
63

61 The function of the moon as measure of the world's time. Rajasthan, 18th century. Ink and colour on paper 5 × 4 in.
62 Diagram of the relationships between sun and moon as measure of the world's time. Rajasthan, 18th century. Ink and colour on paper 4 × 4 in.
63 Astrological horoscope diagram. Rajasthan, Jaipur, 18th century. Ink and colour on paper 24 × 13 in
64 The eternal recurrence of the seven-fold divisions of the Universe as a cosmic river of time and reality, from a Jaina manuscript. Rajasthan. 19th century. Ink on paper 4 × 10 in.
61, 64 Ajit Mookerjee, New Delhi.

64

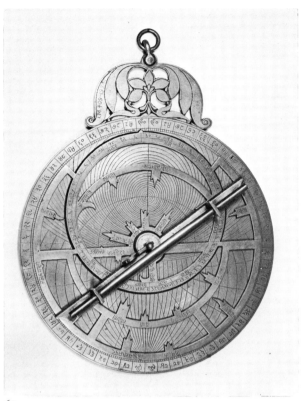

65

67

65 Astrolabe, for the calculation of celestial relationships. Western India, 18th century. Brass, dia. 9 in. Victoria and Albert Museum, London.

66 Globe of the unfolding world. Orissa, 19th century. Papier mâché, dia. 7 in. Victoria and Albert Museum, London.

67 The expanding and enclosing functions of lunar time cycles. Rajasthan, 18th century. Gouache on paper 12 × 8 in. Ajit Mookerjee, New Delhi.

68 The 'qualities' of the days of the lunar month in relation to a grid of symbols of Shiva. Rajasthan, 18th century. Gouache on cloth 12 × 8 in. Ajit Mookerjee, New Delhi.

66

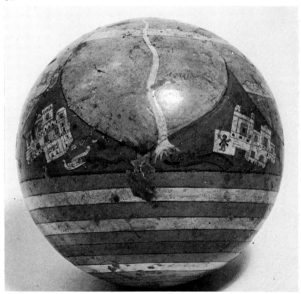

68

VI The subtle body

The central doctrine of Tantra is that the outer world of space and time illustrated by the diagrams is actually an illusory projection from each person around himself; and people are not different from each other as they believe they are. Each individual, by performing Tantrik yoga, can discover that the central column of the radiating world is identical with his own subtle spine. Performing intense inner work, he may then discover that the world which appears projected around him can be withdrawn into a flower-like mandala at the base of his spine. His own inner Creative Goddess, who seems to him like a luminous snake, Kundalini, coiled asleep within that mandala around a lingam, can be awoken by yoga, and will rise up the central channel of his subtle column, passing through a series of inner mandala-transformations as it goes. These, called chakras, culminate in the Thousand-petalled Flower at the crown of the head, where male and female principles unite in bliss; the transcendent, the human and the cosmic become one. In Buddhist Tantra a similar but not identical series of chakras is recognized, in which personified spiritual energies are personalized, transformed and combined. Many of them appear filled with the energies of passion and rage, enveloped in haloes of fire and smoke. The successfully integrated cosmic personality is symbolized here in the supreme, peaceful golden couple at the centre of a mandala of fulfilment.

69 Meditation carpet woven with symbols of elemental regions. Himalaya (?) Wool 70 × 59 in. Eskenazi Ltd., London.

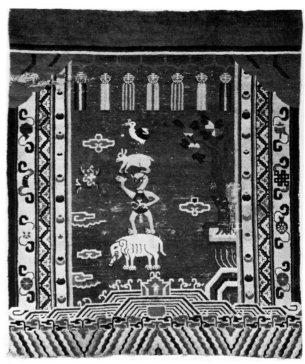

69

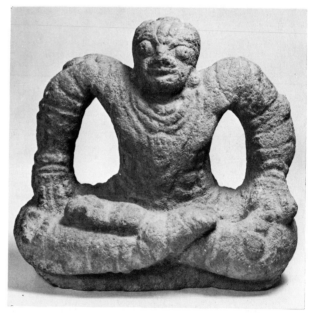

70

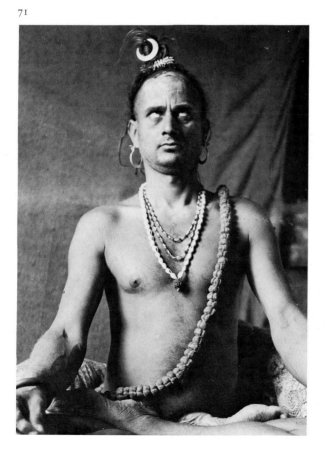

71

70 Yogi. Madhya Pradesh, 13th century. Stone h. 7 in. Ajit Mookerjee, New Delhi.
71 Tantrik Yogi at Banaras, a photograph by Richard Lannoy 1958–60.

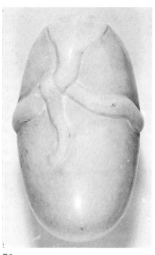

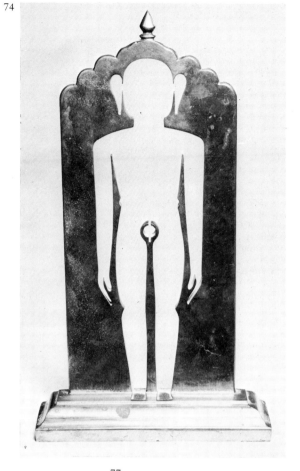

72

73

74

72 The snake Kundalini coiled about a lingam. Banaras, contemporary. Stone h. 7 in. Ajit Mookerjee, New Delhi.

73 Stupa, symbol of the subtle body. Nalanda school, 12th century. Bronze with turquoise h. 7 in. John Dugger and David Medalla, London.

74 Jaina icon of the released spirit. Rajasthan, 18th century. Brass h. 9 in. Ajit Mookerjee, New Delhi.

75 The formula for building the spirit up to liberation. Rajasthan, 18th century. Gouache on cloth 22 × 10 in. Ajit Mookerjee, New Delhi.

76 The bands of progressively denser matter projecting from outer space into the Universe. Rajasthan, c. 1800. Gouache on cloth 10 × 5 in. Ajit Mookerjee, New Delhi.

77 Jaina diagram of the ages and regions through which the self passes in completing its liberation. Rajasthan, 18th century. Gouache on cloth 76 × 32 in. Ajit Mookerjee, New Delhi.

75

76

77

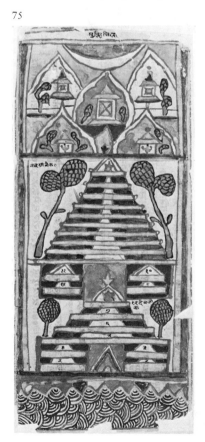

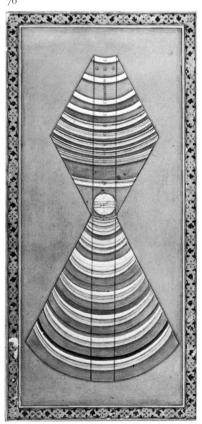

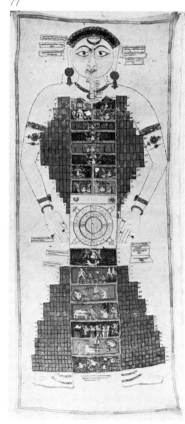

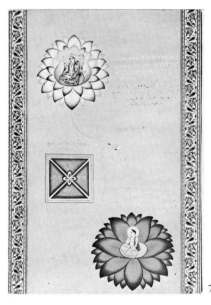

78

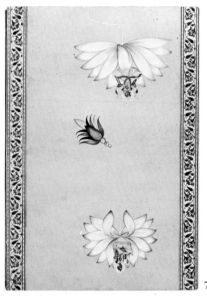

79

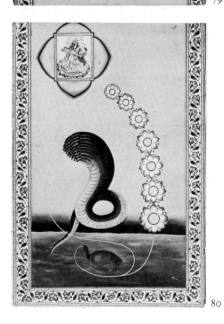

80

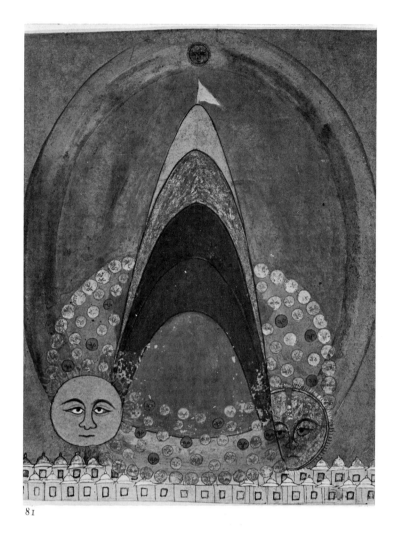

81

82

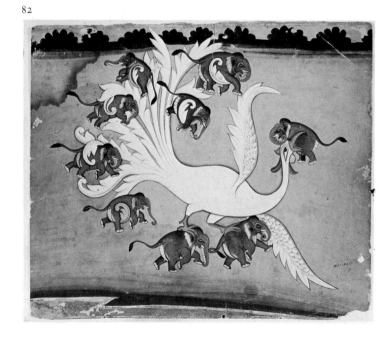

78–80 Three from a set of seven paintings of the meditative series of chakras. Rajasthan, 18th century. Gouache on paper 16 × 11 in. Ajit Mookerjee, New Delhi.
81 Painting representing the spiritual region of enlightenment beyond the crown of the head. Rajasthan, 18th century. Gouache on paper 7 × 6 in. Ajit Mookerjee, New Delhi.
82 Simurgh, bird of realization, holding fast nine elephants symbolizing the lower constituents of the partial self. Gouache on paper 10 × 12 in. Ajit Mookerjee, New Delhi.

83 The terrible deity Yamantaka ('Destroyer of Death') with his female consort, from a manuscript. Nepal, 18th century. Gouache on paper, 3 × 7 in. Ajit Mookerjee, New Delhi.
84 The horrific deity Samvara who has seventy-four arms, with his female Wisdom. Nepal, 17th century. Gouache on cloth 24 × 19 in. Ajit Mookerjee, New Delhi.
85 Icon of Hevajra with his female Wisdom, Nairatmya (self-elimination). Tibet, 16th century. Bronze 9 in. Ajit Mookerjee, New Delhi.

84

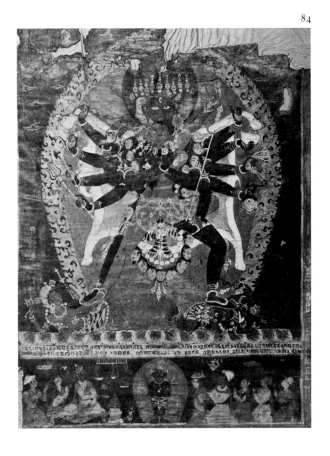

85

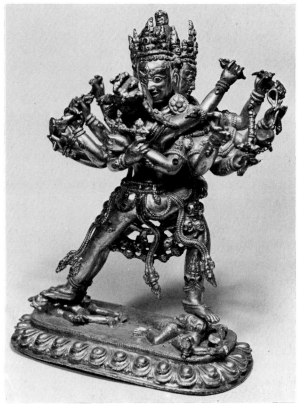

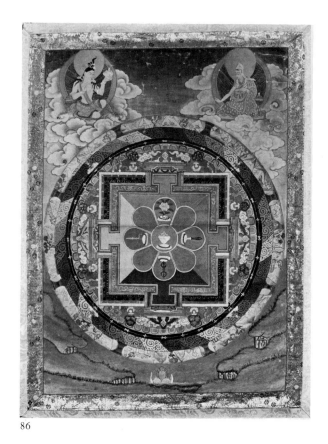

86

88

87

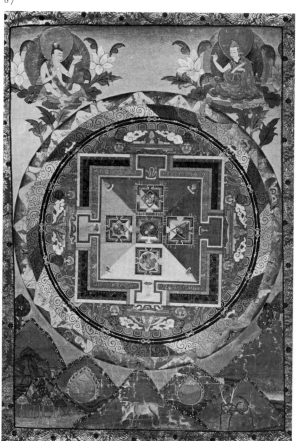

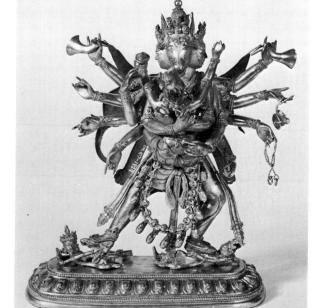

89

86–7 Mandala tankas (from a set of seven). Tibet, 1800. Gouache on cloth 28 × 19 in. John Dugger and David Medalla, London.
88 Painting of hands holding skull cups, coloured to symbolize the five elements. This represents their transformation. Nepal, 18th century. Gouache on cloth 4 × 8 in. Ajit Mookerjee, New Delhi.
89 Icon of an animal-headed Devata dancing in intercourse with his female Wisdom. Tibet, 17th century. Gilt bronze 10 in. Victoria and Albert Museum, London.

VII Meditative diagrams

Yantras are the most important visual means used in Tantrik cult. Among them are the diagrams in which energies are concentrated—visual parallels to the verbal mantras. They focus the energies of the meditator, and correlate all his previous efforts and knowledge into single divine images, which are totally trans-personal. Most are mandalas; and they are often used in cumulative series. The most important of all is the great Shri yantra, composed of nine interpenetrating triangles, symbolic of male and female, which give rise to circuits of other triangles. It presents a condensed image of the whole of creation.

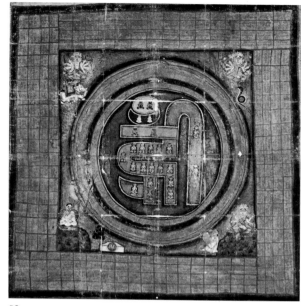

90

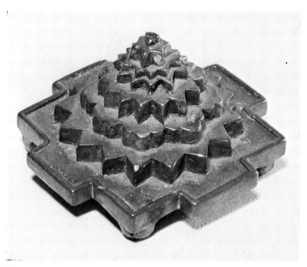

91

92

90 Oṁ yantra. Rajasthan, 18th century. Gouache on cloth 21 × 22 in. Ajit Mookerjee, New Delhi.
91 Shri yantra. Rajasthan, 18th century. Bronze 2 in. Ajit Mookerjee, New Delhi.
92 Kali yantra. Rajasthan, 18th century. Gouache on paper 7 × 7 in. Ajit Mookerjee, New Delhi.

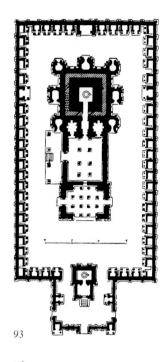

93

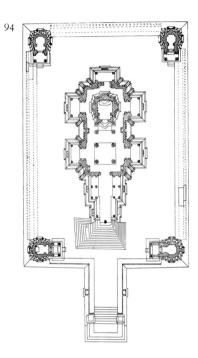

94

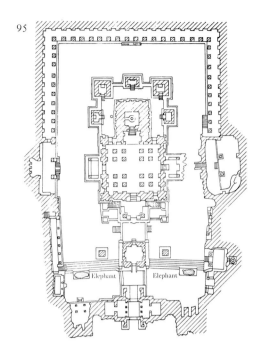

95

Elephant Elephant

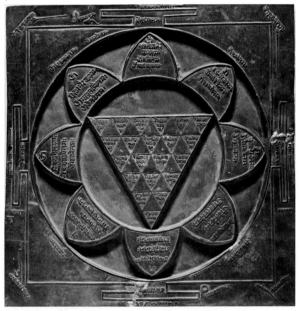

96

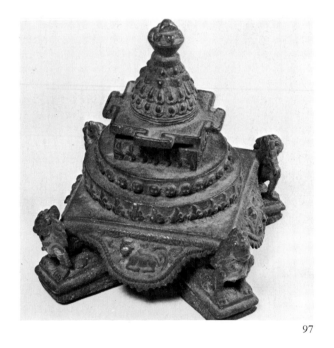

97

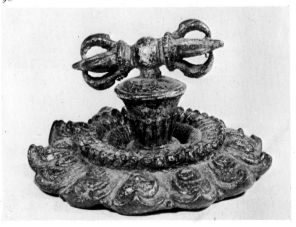

98

93–5 Ground plans of Indian temples, which are themselves yantras.
96 Yantra. Rajasthan, 17th century. Copper plate 14 × 14 in. Ajit Mookerjee, New Delhi.
97 Hindu yantra: temple motif supported by four lions. Nepal, 18th century. Bronze 6 in. John Dugger and David Medalla, London.
98 Vajra emblem on lotus-motif pedestal, Nepal, 15th century. Bronze gilt, h. 4 in. John Dugger and David Medalla, London.

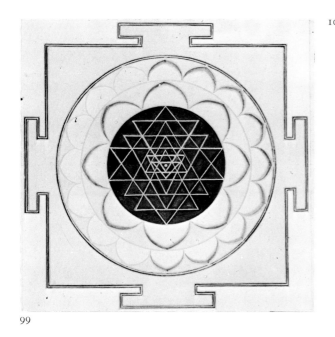

99

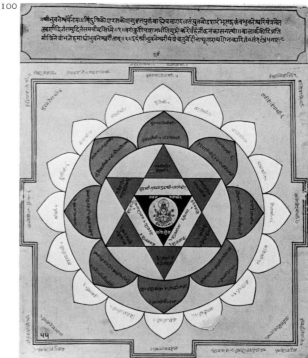

101

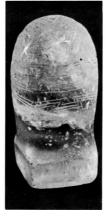

102

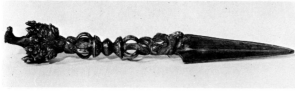

103

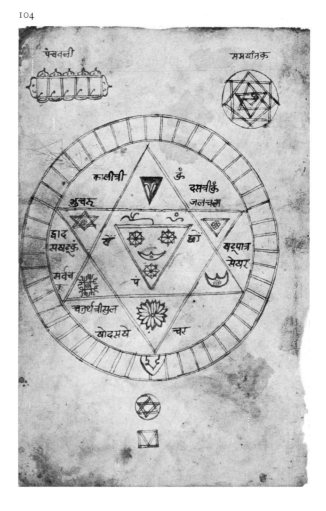

99 Shri yantra. Rajasthan, 18th century. Gouache on paper 8 × 8 in. Ajit Mookerjee, New Delhi.

100 Bhuvaneshvari yantra. Rajasthan, 18th century. Gouache on paper 13 × 11 in. Ajit Mookerjee, New Delhi.

101 Small Buddhist yantra device. Tibet, 19th century. Paint on cloth 4 × 4 in. John Dugger and David Medalla, London.

102 Lingam, engraved with Shri yantra, probably used as initiation instrument for female Tantrikas. Rajasthan, 17th century. Rock crystal 3 in. Ajit Mookerjee, New Delhi.

103 Phur-bu, Tibetan magical dagger incorporating the power of the mantra Hum. Tibet, 18th century. Bronze 19 in. Gulbenkian Museum of Oriental Art, Durham.

104 Meditative diagram. Nepal (?). Ink on paper 9 × 8 in. John Dugger and David Medalla, London.

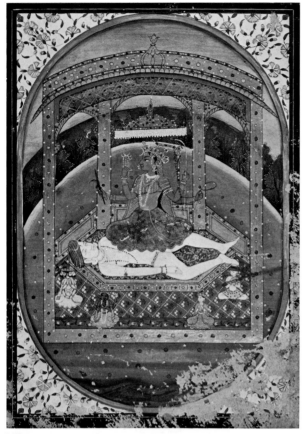

105

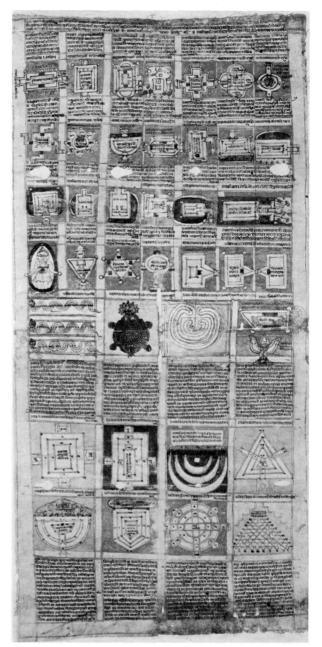

106

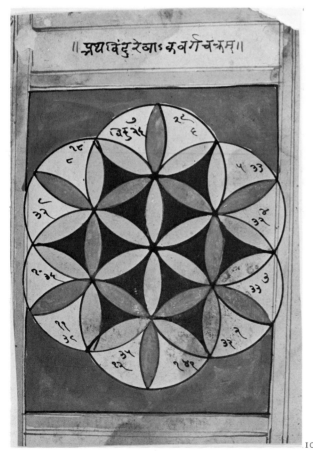

107

105 Mahavidya icon. Kangra, Himachal Pradesh, 18th century.
Gouache on paper 7 × 5 in. Ajit Mookerjee, New Delhi.
106 Sheet of yantras illustrating the organs and functions
whereby the world is created. Rajasthan, 1769. Ink and colour
on paper 43 × 20 in. Ajit Mookerjee, New Delhi.
107 One of fifteen yantras of the process of creation. Rajasthan,
19th century. Ink and colour on paper 11 × 7 in. Ajit Mookerjee,
New Delhi.

VIII The approach to unity

The processes whereby the creative act of the divine Brahman unfolds into the circuits of space and time can be traced back, through patterns of form, to an original splitting into two. This is symbolized both as male and female, but also as the dividing of an anthropomorphic image of the deity down the centre. Another, parallel, imagery represents the universe as developing from a cosmic egg, within which crystallize bands and regions, the first stages of ever more particularized entities.

Imagery for the unimaginable may appear deceptively simple. The cosmic egg and the self-originated lingam with no 'standing-place' assimilate to each other. The symbolism of red and white, female and male, fuse. The whole potential cosmos is revealed at an infinitely remote existential stage by the flashes which appear on the surface of the lingam-egg. Small banded stones, or pebbles containing ammonites—pierced to reveal the chambering within—signify the notion of that which contains all. The wise, it is said, survey the radiance of the Origin without words. In India, the mantra 'Oṁ' is felt to come nearest to indicating it.

The subtlest imagery of all traces creation back to a Primal Vibration, a point we must call 'sound'; from it the infinite variety of the actual develops as patterns of wave and interference. Indian and Tibetan art symbolize this Primal Vibration by the conch-shell trumpet or double-drum. It is both origin of the world and goal of the Tantrika's efforts.

108 Supreme deity, Shiva and Parvati, half male, half female. Madras, 11th century. Bronze h. 46 in. Madras Museum.
109 Supreme deity, Shiva and Kali. Kalighat, Calcutta, 19th century. Watercolour on paper 15 × 10 in. Ajit Mookerjee, New Delhi.
110 Hari-Hara icon (Vishnu and Shiva), creator and destroyer, both male, joined. Jammu-Kashmir, 17th century. Gouache on paper 7 × 7 in. Ajit Mookerjee, New Delhi.

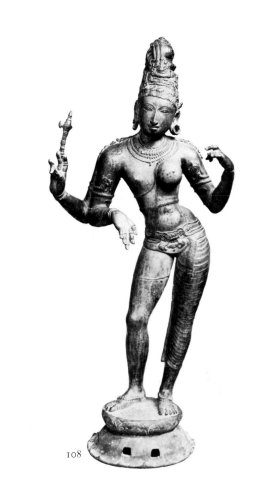

108

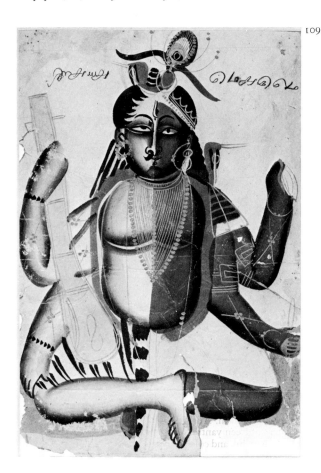

109

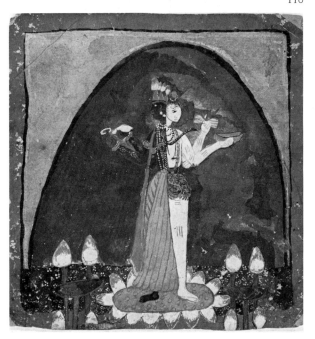

110

111

111 Cosmic egg or self-originated lingam. Banaras, age unknown. Stone 5 in. Ajit Mookerjee, New Delhi.

112 Painting illustrating the separation of atoms from the waters of non-entity, Jaina in ideology. Rajasthan, 18th century. Gouache on paper 10 × 4 in. Ajit Mookerjee, New Delhi.

113–14 Leaves from a manuscript series illustrating the processes of evolution of the Universe. Western India, c. 1700. Gouache on paper 10 × 5 in. Ajit Mookerjee, New Delhi.

115 Block for printing ritual textiles. Gujarat, 18th century. Metal on wood 5 × 6 in. Ajit Mookerjee, New Delhi.

116 Painting representing a stylized form of the syllable 'Oṁ' with its resident deities, from a book. Rajasthan, 18th century. Gouache on paper 9 × 6 in.

117 The Primal Light. Deccan, 18th century. Gouache and gold on paper 11 × 7 in. Ajit Mookerjee, New Delhi.

118 Cosmic sun. Tanjore, 18th century. Wood, painted 12 in. Ajit Mookerjee, New Delhi.

113

114

112

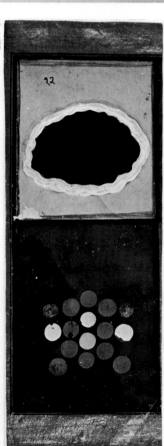

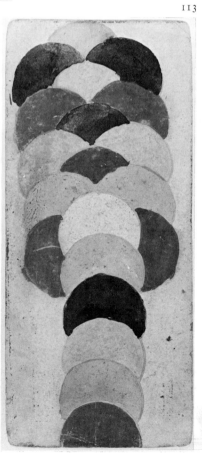

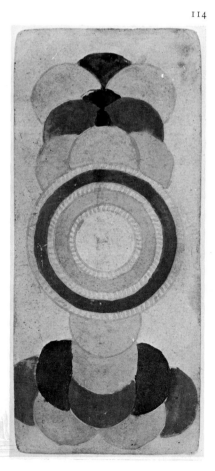

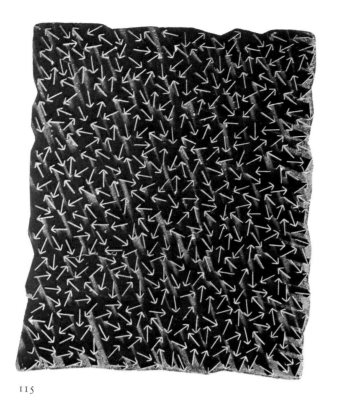

115

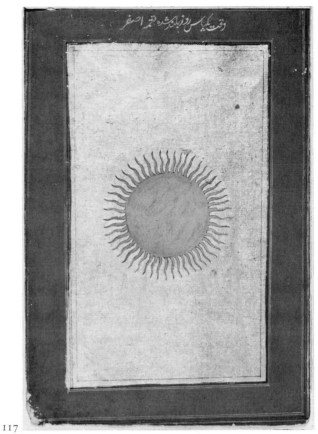

117

116

118

127

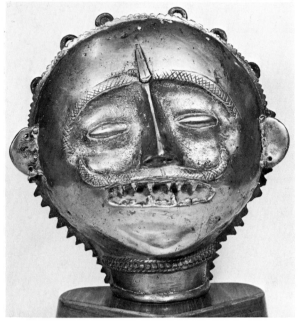

119

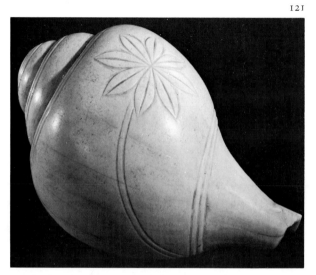

121

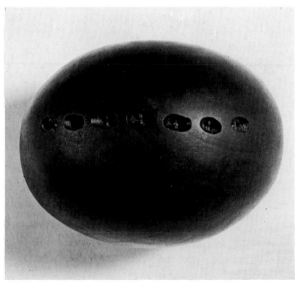

120

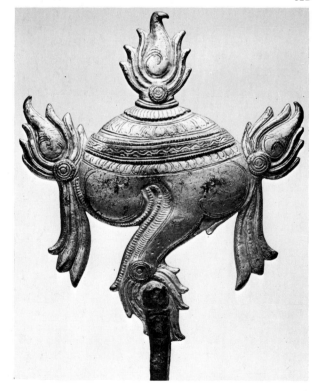

122

119 Shiva as the deity of the lingam. Rajasthan, 17th century. Brass 13 in. Ajit Mookerjee, New Delhi.
120 Sacred stone containing ammonites, pierced. Age and provenance unknown. Stone 6 in. Ajit Mookerjee, New Delhi.
121 Natural shell trumpet. 19th century. 6 in. Private collection.
122 Emblem of the conch shell, radiating glory. South India, 16th century. Gilt bronze 11 in. Ajit Mookerjee, New Delhi.